MICHELLE A. GILDERS

# THE NATURE OF
# GREAT APES

## OUR NEXT OF KIN

GREYSTONE BOOKS

Douglas & McIntyre Publishing Group

Vancouver/Toronto/New York

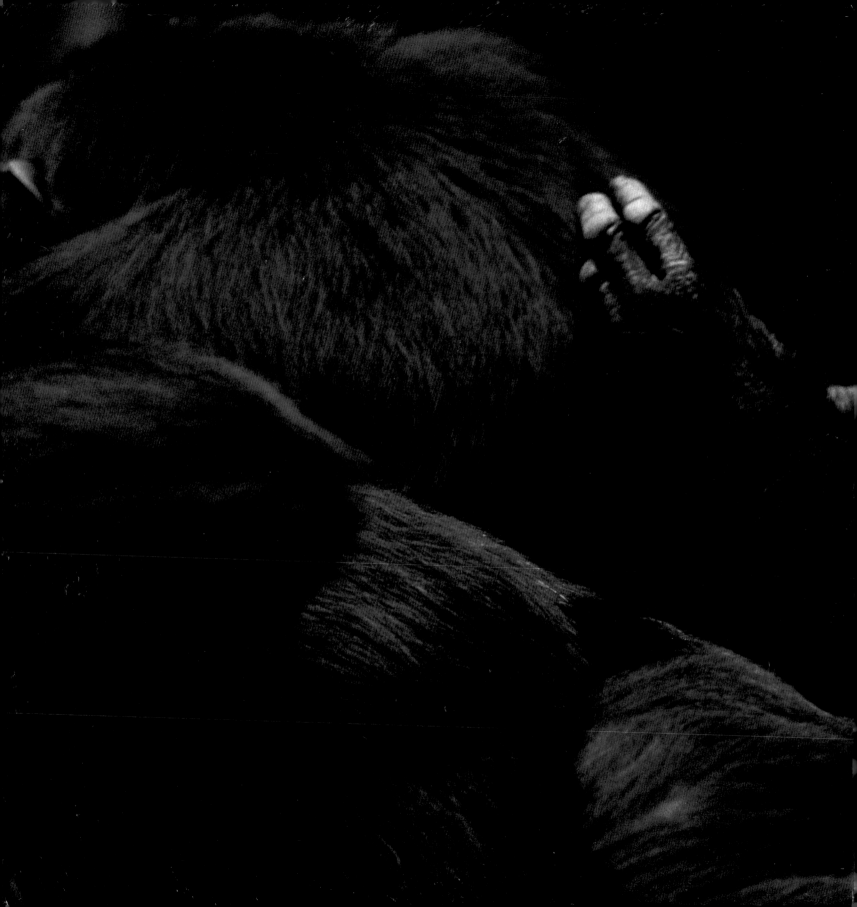

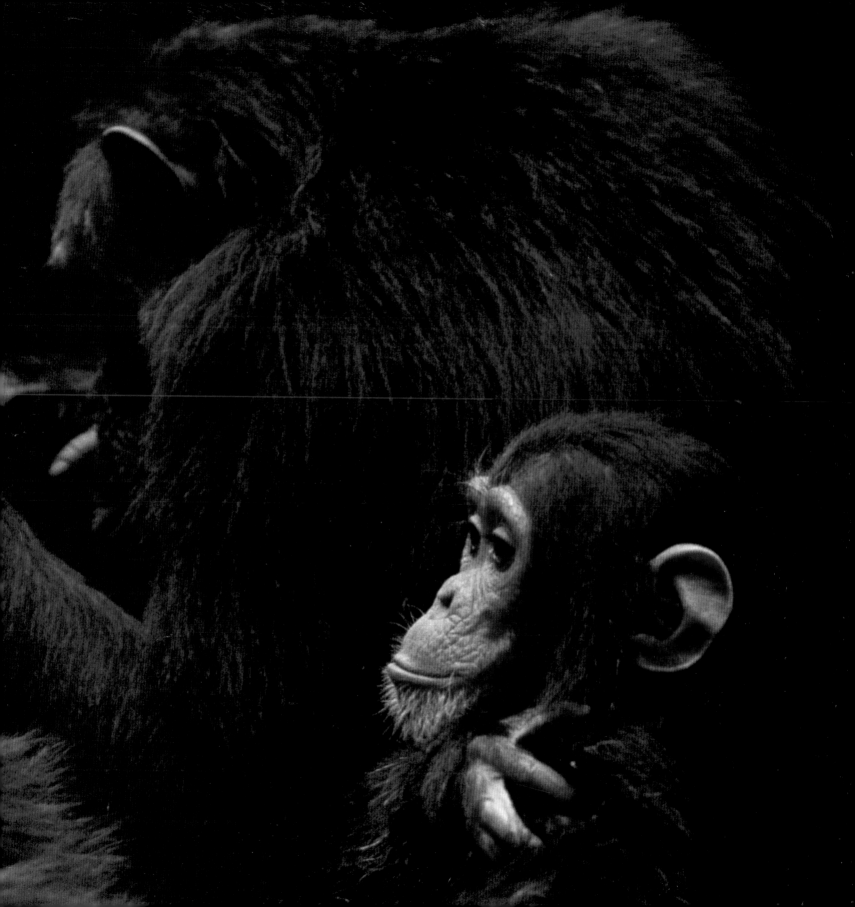

Greystone Books
A division of Douglas & McIntyre Ltd.
2323 Quebec Street, Suite 201
Vancouver, British Columbia V5T 4S7

CANADIAN CATALOGUING IN PUBLICATION DATA

Gilders, Michelle A., 1966–
   The nature of great apes

   Includes bibliographical references and index.
   ISBN 1-55054-762-3

   1. Apes. I. Title.
QL737.P96G54 2000     599.88    C99-911127-2

Library of Congress Cataloguing-in-Publication Data available upon request

Design by Val Speidel
Front cover photograph by Kennanward.com
Back cover photograph by Anup and Manoj Shah
Printed and bound in Hong Kong by C & C Offset Printing Co. Ltd.
Printed on acid-free paper ∞

We gratefully acknowledge the financial support of the Canada Council for the Arts, the British Columbia Ministry of Tourism, Small Business and Culture and the Government of Canada through the Book Publishing Industry Development Program (BPIDP) for our publishing activities.

# CONTENTS

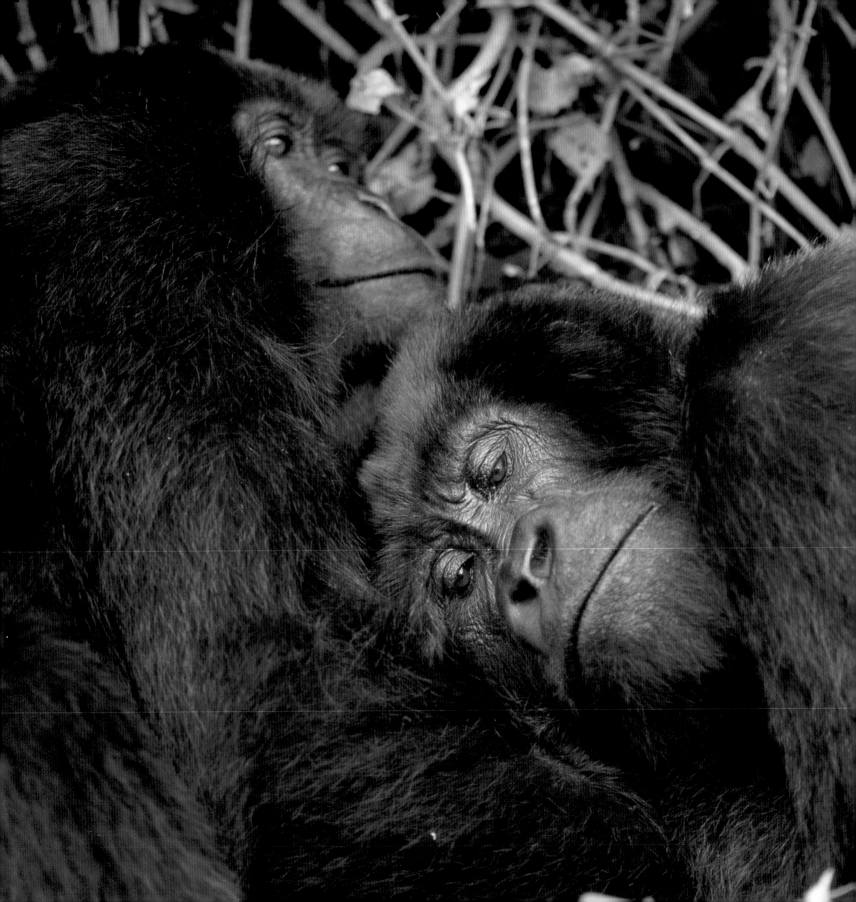

TO JOHN WILSON
A GREAT FRIEND,
EVEN AT GREAT DISTANCES

# ACKNOWLEDGMENTS

A book such as this draws on decades of research that is often conducted under arduous (and even dangerous) conditions. There is not enough space here to personally thank all of the researchers whose work I have reviewed while preparing this volume. However, in the course of my reading I had the pleasure of poring over more than 150 scientific research papers, 25 academic journals, a cumulative 65 years of published data, and some 45 individual books.

I would like to thank the MacKimmie Library, University of Calgary, for giving me access to so much of this work. My thanks go to my reviewers: John Fleagle (Department of Anatomical Sciences, State University of New York), Alexander Harcourt (Anthropology Department, University of California, Davis), Michael Huffman (Primate Research Institute, Kyoto University), Jennifer Parnell, Jennifer Purl, Craig B. Stanford (Assistant Professor of Anthropology, University of Southern California), Gary M. Stolz (U.S. Fish and Wildlife Service/Associate Professor, University of Idaho), Michael Tomasello (Max Planck Institute for Evolutionary Anthropology, Leipzig), Declan Troy, Claire Waddoup, Andrew Whiten (Scottish Primate Research Group, St. Andrews), and John Wilson. I would also like to thank Rob Sanders, Nancy Flight, and Lucy Kenward at Greystone Books, Vancouver, B.C., and Candace Savage (general editor of the Greystone *Nature* series). As always, any mistakes in the text remain my own.

FACING PAGE

*Mountain gorillas are the rarest of the world's apes. Fewer than 650 survive in the Virunga Mountains of Central Africa.* KONRAD WOTHE/MINDEN PICTURES

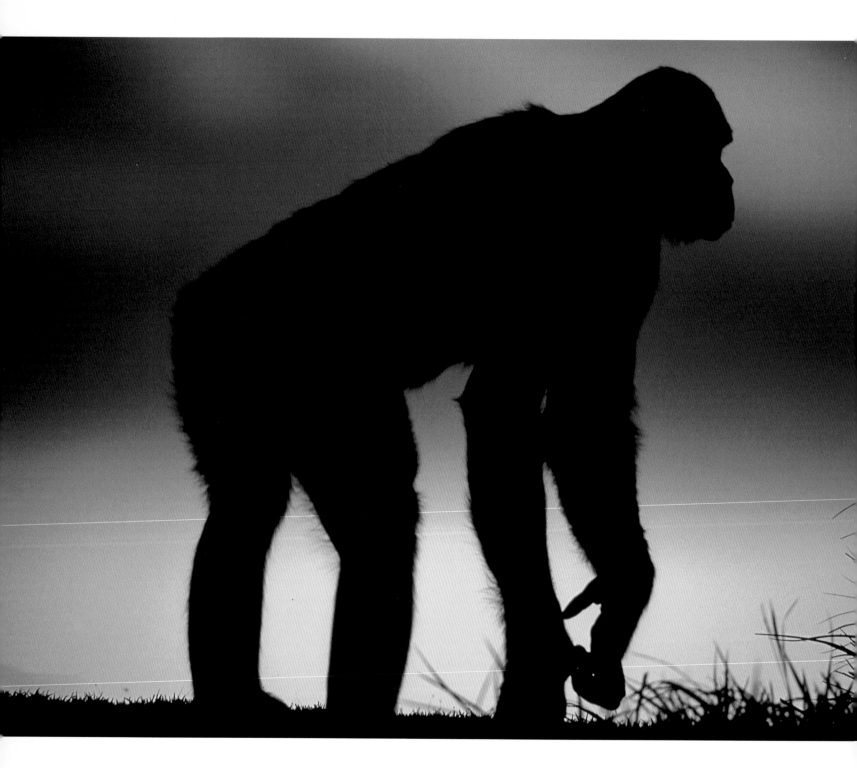

# THE EVOLVING APE

## *Chapter One*

*D*awn in the high mountain rain forests comes slowly. Rain clouds darken the sky, shrouding the mountain in mist and hiding the emerging sun. Gradually, as the light filters through, definition comes to the forest. Everything is muted here, damp, soft. A thousand shades of green, layer upon layer of verdant life. There are movements on the forest floor, slight stirrings of life, as the inhabitants rise. The mountain gorillas wake slowly. They call softly to those that are out of sight. They will spend the day eating and resting. Youngsters play-fight, testing their strength, cupping their hands and beating on their small chests, pok-pok, under the ever-watchful eye of the commanding silverback. Rain falls often, and the apes sit stoically, their arms folded against the cold, as rain drips from their long black coats.

Most people have never met their closest relatives—that is, their closest animal relatives. Orangutans, gorillas, chimpanzees, bonobos (also known as pygmy chimpanzees), and humans are all great apes. Many people would rather forget the piercing eyes and familiar faces of the other apes that are the all-too-similar mirrors of our own. But there is no escaping our genes.

Through the pioneering work of such biologists as Dian Fossey and George Schaller (mountain gorillas), Jane Goodall (chimpanzees), Takayoshi Kano (bonobos), and Biruté Galdikas (orangutans), we now have a better understanding of our closest animal relatives. With many of the apes threatened with extinction, such insights will be crucial to their survival.

Great apes, or Hominidae, make up one of the thirteen families in the mammalian order Primates, which includes tarsiers, lemurs, and monkeys. This family, which once contained only one species, humans (*Homo sapiens*), has been expanded to include orangutans (*Pongo pygmaeus*), gorillas (*Gorilla gorilla*), chimpanzees (*Pan troglodytes*), and bonobos (*Pan paniscus*). Formerly, these non-human apes belonged to a separate primate family, Pongidae, and although some biologists and anthropologists continue to classify the apes in this way, many now group both apes and humans in a single family in recognition of their close evolutionary history. A second family, Hylobatidae, encompasses the gibbons, or lesser apes.

Primates probably evolved from primitive insectivores in the early Eocene epoch, 53 million years ago. These animals likely resembled modern-day lemurs and tarsiers and were the ancestors of all primates, including apes. Sixteen million years later, in the early Oligocene era, monkeys and apes, known collectively as higher primates, had evolved.

During the Miocene, 24 million years ago, primitive apes and monkeys could be found throughout East Africa. It is believed that all modern great apes trace their heritage to these animals. Apes were abundant during this time, whereas monkeys were comparatively rare. Sixteen to ten million years ago monkeys began to outnumber apes, and they still do so today.

As climatic changes swept across Asia and Africa later during the Miocene

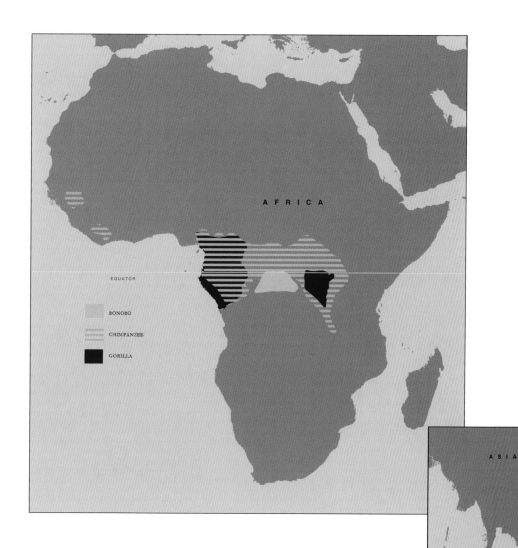

AFRICA

EQUATOR

BONOBO

CHIMPANZEE

GORILLA

ASIA

EQUATOR

Sumatra          Borneo

ORANGUTAN

DISTRIBUTION OF
GREAT APES
*Orangutans live only on*
*Borneo and Sumatra. Gorillas,*
*chimpanzees, and bonobos*
*occupy more varied African*
*terrain, from savanna-grass-*
*lands to mountain rain forests.*
*Adapted from Eugene Linden,*
*March 1992, "A Curious*
*Kinship: Apes and Humans,"*
National Geographic

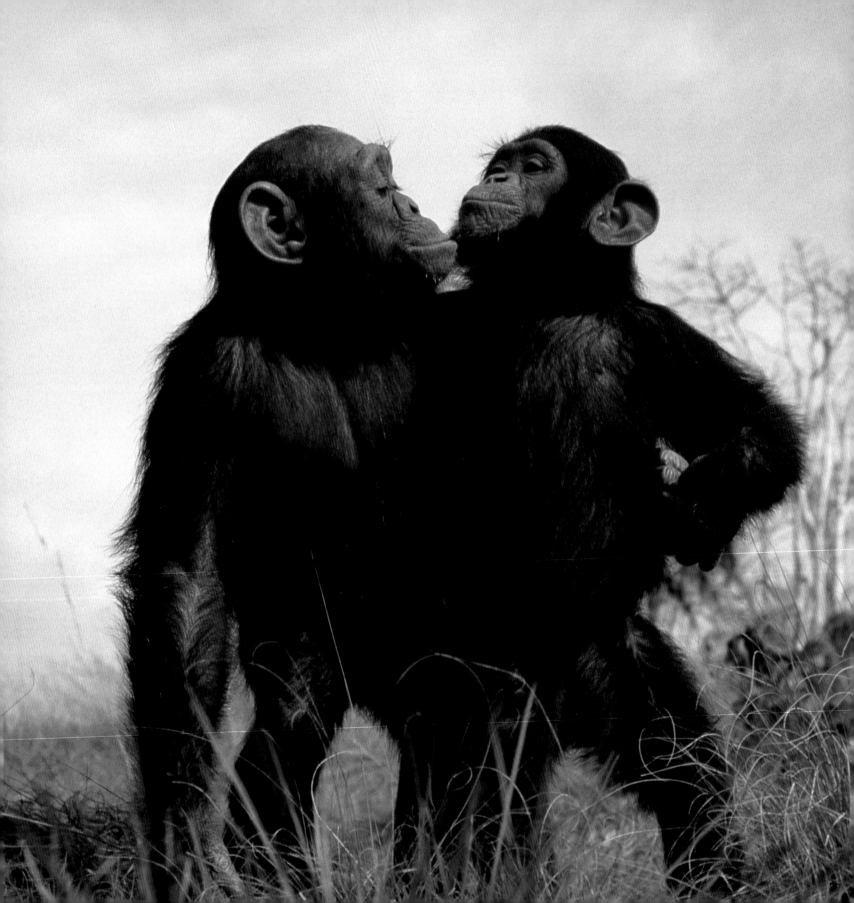

OR BONOBOS BUT

WALKING UPRIGHT LIKE

HUMANS, THIS GENUS,

WHICH INCLUDES A

NUMBER OF DIFFERENT

SPECIES, MAY WELL BE

OUR DIRECT HUMAN

ANCESTOR.

FACING PAGE

*Two young orphan chim-*
*panzees bond at a sanctu-*
*ary in the Republic of the*
*Congo. Chimpanzees share*
*98.4 percent of their DNA*
*with humans. Humans*
*are so closely related to*
*chimpanzees that blood*
*transfusions are possible*
*between our species.*

MICHAEL NICHOLS/NGS

IMAGE COLLECTION

period, apes diversified, creating a host of new species that would ultimately become the modern great apes. Among the apes that arose during the Miocene were the first hominoids, or human-like apes, including a group known as dryomorphs that lived in the African forests.

As recently as the 1970s, scientists believed that humans diverged from the other apes 28–20 million years ago. Today a rich fossil record shows that all modern apes—including humans—have many more recent relatives. The ape (and thus the human) family tree is really more of a bush. The evolution of modern apes and humans was not linear but involved a great deal of branching. Most of these species became extinct, but all shared a common ancestor.

Gibbons diverged from the other apes between 20 and 12 million years ago. It was also during that time that the newly discovered baboon-like animal *Equatorius africanus*, once found in East Africa, became the first ape to leave the trees and live, at least part of the time, on the ground.

Among the modern apes, orangutans, isolated in what is now Asia, were the first of the great apes to diverge from the apes' common ancestor, between 10 and 7 million years ago. This period—the mid-to-late Miocene—saw the climate become progressively drier and cooler. The tropical rain forests retreated, drawing closer to the equator, and elsewhere savanna-grasslands encroached upon the woodlands. Gorillas were the next of the great apes to emerge in a form that we would recognize today—doing so between 8 and 6 million years ago.

Shortly after the emergence of gorillas, *Australopithecus* appeared in Africa. Behaving a lot like chimpanzees or bonobos but walking upright like humans, this genus, which includes a number of different species, may well be our direct human ancestor. Australopithecine remains as old as the 4.2–3.9-million-year-old *Australopithecus anamensis* and as young as 1.8 million years old have been unearthed in Ethiopia, Tanzania, Kenya, and Chad. But the 3.3-million-year-old

NOT ONLY ARE AFRICAN

APES GENETICALLY

CLOSER TO HUMANS

THAN THEY ARE TO

ORANGUTANS, BUT

CHIMPANZEES AND

BONOBOS ARE MORE

CLOSELY RELATED TO

HUMANS THAN ANY

OTHER ANIMAL

ON EARTH.

*Australopithecus afarensis* skeleton, dubbed Lucy, whose body, skull, and lower limbs are similar in size to those of modern bonobos, is still the best known.

Although no one can say exactly who chimpanzees', bonobos', and humans' direct shared ancestor was, a 4.4-million-year-old hominoid called *Ardipithecus ramidus* found in Ethiopia lived close to the time, estimated at 4.7 million years ago, when chimpanzees became a separate species. Only between 2.5 and 1.5 million years ago did the ancestral chimpanzee split into two distinct forms that we know today as bonobos and chimpanzees.

The study of DNA shows just how closely related the great apes really are. When two species are in the process of branching off from a common ancestor, they begin at a point where they are identical—their genes are the same. However, over time, independent mutations occur in the DNA and such changes are maintained by reproductive isolation. These mutations also occur at a regular, predictable rate, allowing the changes in DNA to be used like a molecular clock by researchers.

Orangutans, the species that branched off the family tree first, have DNA that differs from the other great apes' genetic material by 3.6 percent. Gorillas vary from chimpanzees, bonobos, and humans in 2.3 percent of their DNA. A mere 1.6 percent difference in genetic material separates humans from chimpanzees and bonobos. The two *Pan* species differ in just 0.7 percent of their DNA, demonstrating their close physical and evolutionary heritage.

Not only are African apes genetically closer to humans than they are to orangutans, but chimpanzees and bonobos are more closely related to humans than any other animal on Earth. Humans are closer to chimpanzees and bonobos than zebras are to horses. Normally, genetic relationships as near as those between chimpanzees, bonobos, and humans would place them in the same genus—which would make humans *Pan sapiens* or chimpanzees and bonobos *Homo troglodytes* and *Homo paniscus*, respectively.

FACING PAGE

*Despite the fact that gorillas and humans took different evolutionary paths between 8 and 6 million years ago, it is still possible to see shades of our common ancestry in their faces.* ART WOLFE

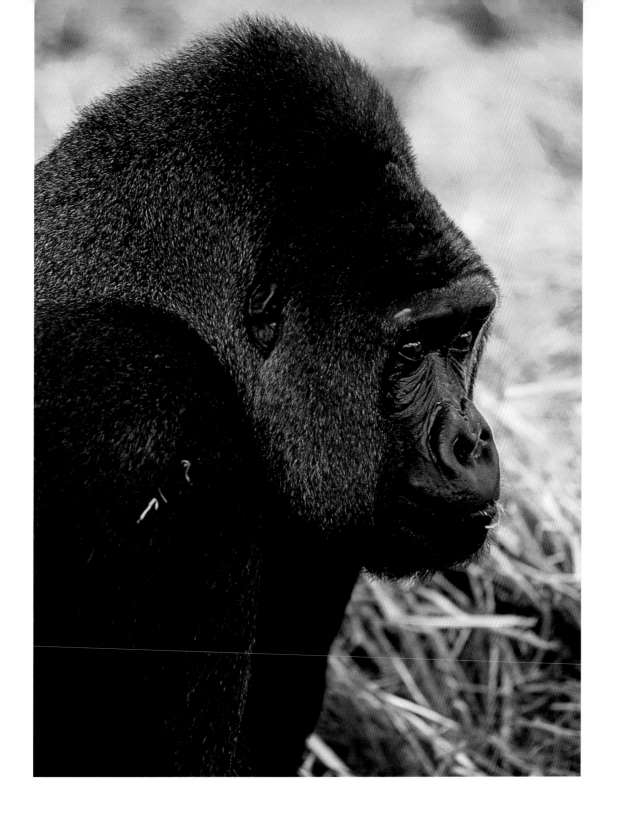

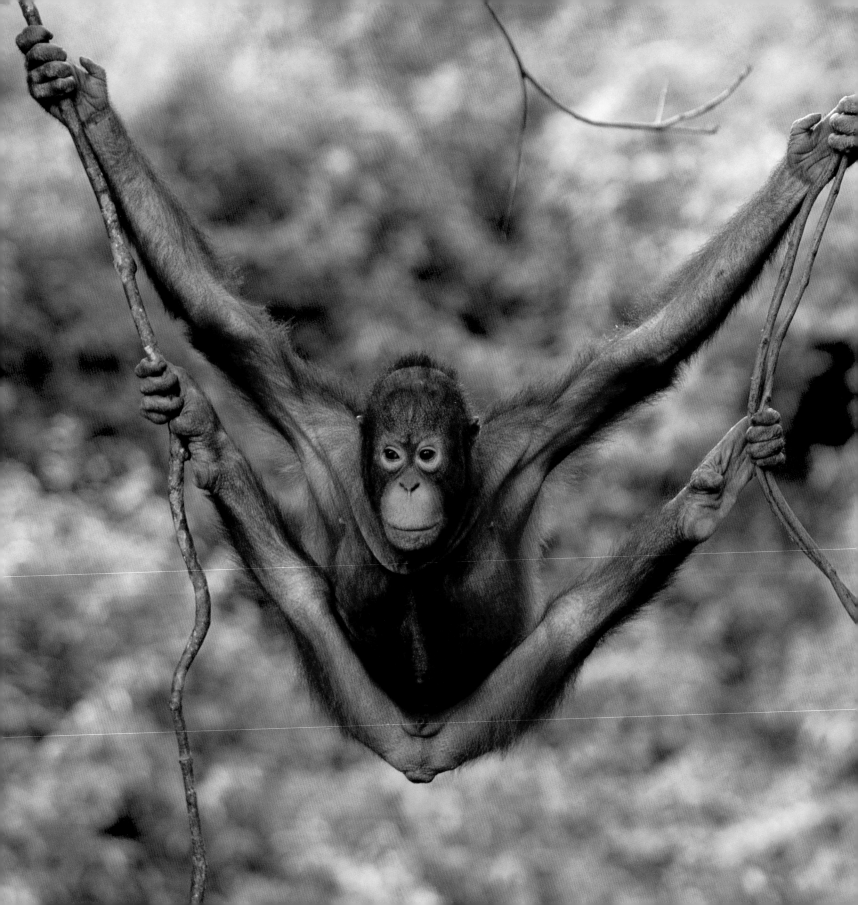

## SPECIES SPECIFICS

Great apes share a number of characteristics with other primates. Their brains are significantly larger, as a proportion of body weight, than those of other terrestrial mammals. Like other primates, they also have a long gestation period, considering the female's size, and their offspring develop fairly slowly after birth, depending on their mother for a number of years.

Physically, all great apes' forelimbs are longer than their hindlimbs, and their shoulder and wrist joints are flexible so that apes can travel with ease from tree to tree. Great apes easily grasp branches and manipulate small objects with their long, powerful fingers and long, curved toes because they have opposable thumbs and "big toes" that can touch each of the other digits on the hand or foot. Like other primates, apes have nails instead of claws to support their fingertips and reduce slippage when they climb.

Primates' eyes are at the front of their skull rather than off to the side, giving them binocular vision. With this overlapping field of vision, great apes can see in three dimensions to find fruit or insects in the dark forest and to climb along narrow branches. Primates lack a well-developed sense of smell, but not because a sense of smell is unimportant to them. It is likely that they lost a highly developed olfactory sense because, with their front-facing eyes, there is simply little room for a complex olfactory apparatus.

Like many primates, great apes are sexually dimorphic—differences in size

THE NAME ORANGUTAN

MEANS "PERSON OF THE

FOREST" IN MALAY. IT IS

AN APT NAME FOR THESE

TROPICAL RAIN FOREST

INHABITANTS

OF BORNEO AND

NORTHERN SUMATRA IN

SOUTHEAST ASIA.

and/or appearance distinguish the sexes. Males are larger than females and they often have well-developed canine teeth, especially in species in which males compete violently for females, or in which females actively select their own mates. Among great apes, orangutans and gorillas are much more sexually dimorphic than either chimpanzees or bonobos.

Great apes differ from monkeys in their lack of tails, although they do possess a tailbone. Even the tailless monkeys bear remnant tails. Apes also climb differently. Whereas monkeys scurry over branches with their backs horizontal to the ground, apes usually clamber through the trees with their backs vertical, using all four limbs to support their weight.

## Shaggy Orangutans

The name orangutan means "person of the forest" in Malay. It is an apt name for these tropical rain forest inhabitants of Borneo and northern Sumatra in Southeast Asia. Ten thousand years ago, when lower sea levels connected Sumatra and Borneo to the Asian subcontinent, orangutans ranged over much of the mainland, including Malaysia, Thailand, Vietnam, Laos, Myanmar, and southern China.

Today orangutans are the largest living tree-dwelling mammals. They stand 1.25–1.50 meters (4–5 feet) tall, and their arms have a spread of more than 2.25 meters (7.4 feet). Males and females look quite different—adult males weigh 70–80 kilograms (154–176 pounds), twice the size of the 35-kilogram (77-pound) females, and roughly comparable in size to an adult man. When they mature, most male orangutans develop secondary sexual characteristics, including a bony ridge at the top of the skull known as a sagittal crest, facial hair, fleshy cheek pads known as flanges, and throat pouches called laryngeal sacs. Under certain conditions a male that is in all other respects mature, including sexually, may not develop these features, remaining in appearance a subadult.

FACING PAGE

*The shaggy coat of Sumatran orangutans keeps them warm in their high-altitude habitats. Although found in tropical regions, orangutans live at elevations up to 1000 meters (3,300 feet); under cloudy skies the weather can turn surprisingly cool.*

WARDENE WEISSER/

BRUCE COLEMAN INC.

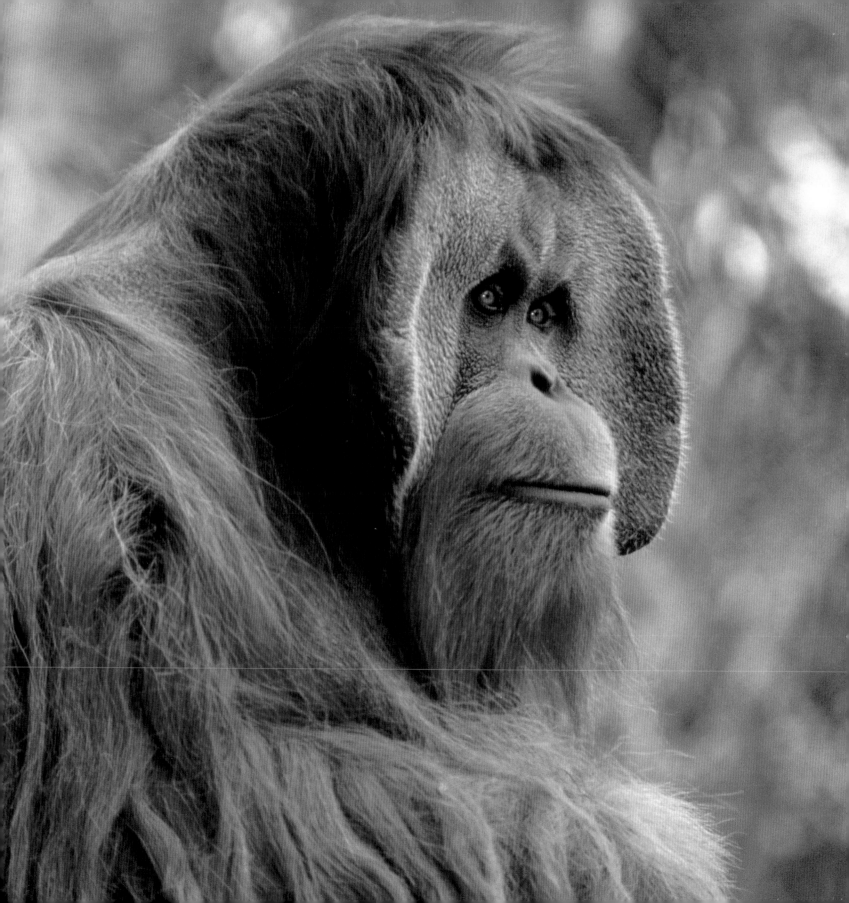

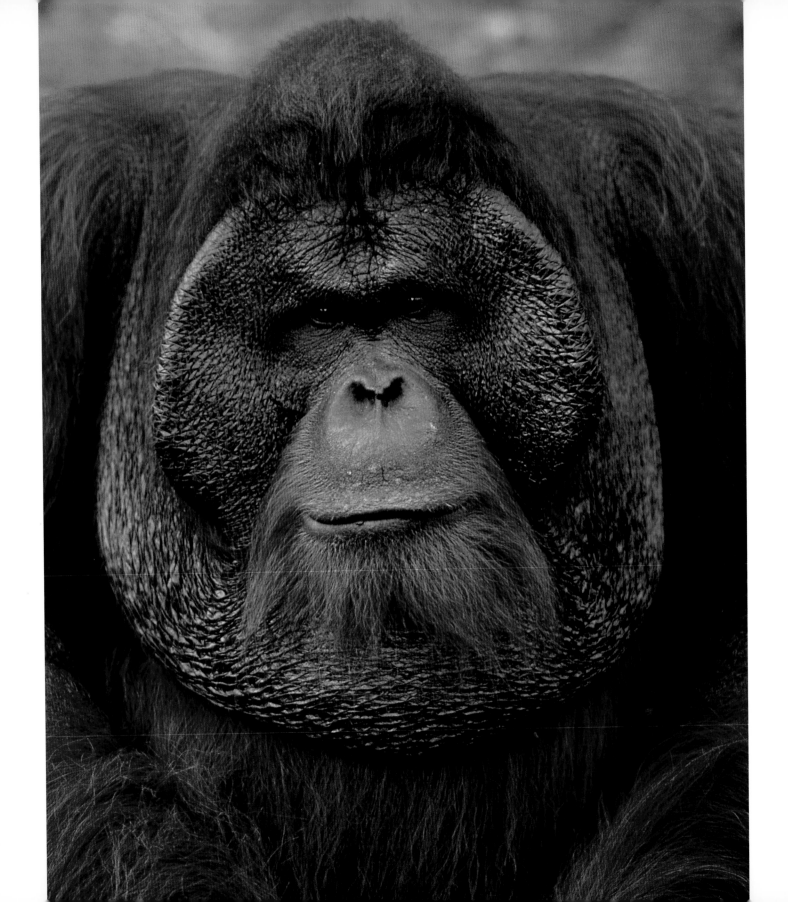

Physically, the orangutan's two subspecies, the Sumatran orangutan (*Pongo pygmaeus abelii*) and the Bornean orangutan (*Pongo pygmaeus pygmaeus*), look quite different. Each went its separate way during the Pleistocene, 1.5 million years ago, and some primatologists consider the two orangutans as different from each other as chimpanzees are from bonobos. Bornean orangutans' long coarse hair ranges in color from red to a deep maroon or blackish brown, whereas Sumatran animals are lighter red or cinnamon-colored with fleecier coats, probably to keep them warm in their high-altitude, 1000-meter (3300-foot) plus habitats. Both Sumatran males and females have noticeably hairy faces, although males' beards are more pronounced than those of females. In contrast, the faces and cheek flanges of Bornean orangutans are naked or only sparsely covered with hair.

Flanges are unique to male orangutans and are formed by fat deposits that lie under the skin between the eyes and ears. Sumatran males' flanges grow laterally, making their faces round or plate-shaped, whereas Bornean animals' pads spread outward, giving them more convex or bowl-shaped visages. Bornean males develop cheek flanges at age eight, and they are fully formed by age fifteen. Sumatran males do not develop flanges until age ten, and they can take more than a decade to grow completely.

Flanges may serve to focus the energy of the males' distinctive long call, the loud booming sound that alerts male competitors and female mates to their presence. To amplify their calling, males develop a large throat pouch that inflates when they vocalize. Bornean males' laryngeal sacs are much more prominent, and their long calls more drawn out, whereas the Sumatran males' calls are shorter and faster to reach across longer distances in the mountains where they live. Long calls may be heard more than a kilometer (0.6 mile) away.

Orangutans live in tropical rain forests dominated by towering 40–60-meter (130–200-foot) emergent trees that protrude through the lower canopy. Because

orangutans favor fruit, such as figs, that grow in the middle canopy, and they are often too heavy to easily climb any higher, they usually stay between 10 and 25 meters (33 and 83 feet) up. Orangutans climb using all four of their limbs and often feed using three just for support. Even so, they move slowly and, although they spend more time in the trees than other apes, orangutans seem to fall often. In one study, 46 percent of all museum skeletons had at least one bone fracture, compared with 33 percent of chimpanzees and 15 percent of gorillas. When on the ground, orangutans are fist walkers. This gait is unique among great apes; the other species curl their fingers towards their palms and walk on their knuckles.

## Majestic Gorillas

Although they range from sea level to 3400 meters (11,220 feet), the largely ground-dwelling gorillas favor open-canopy, lowland rain forests rich in shrubs and other herbaceous, non-woody vegetation. They tend to avoid the dense canopy and dark understory of primary tropical forests.

Gorillas once existed across equatorial Africa, from western Uganda and the Democratic Republic of the Congo (Congo/Zaire) to the Republic of the Congo, Gabon, Cameroon, and southeastern Nigeria. Today eastern lowland, or Grauer's, gorillas (*Gorilla gorilla graueri*), which have been geographically isolated for several hundred thousand years, live only in the far eastern sections of Congo/Zaire, and western lowland gorillas (*Gorilla gorilla gorilla*) are found 1000 kilometers (620 miles) to the west. Mountain gorillas (*Gorilla gorilla beringei*) remain only in the high-altitude Virunga Volcanoes Conservation Area that overlaps Congo/Zaire, Uganda, and Rwanda, and possibly in Uganda's Bwindi Impenetrable Forest National Park. The Nigerian gorilla is also genetically distinct from the western lowland gorilla and may, one day, be recognized as a separate subspecies.

Gorillas are the largest great apes. They stand 1.25–1.75 meters (4.1–5.8 feet)

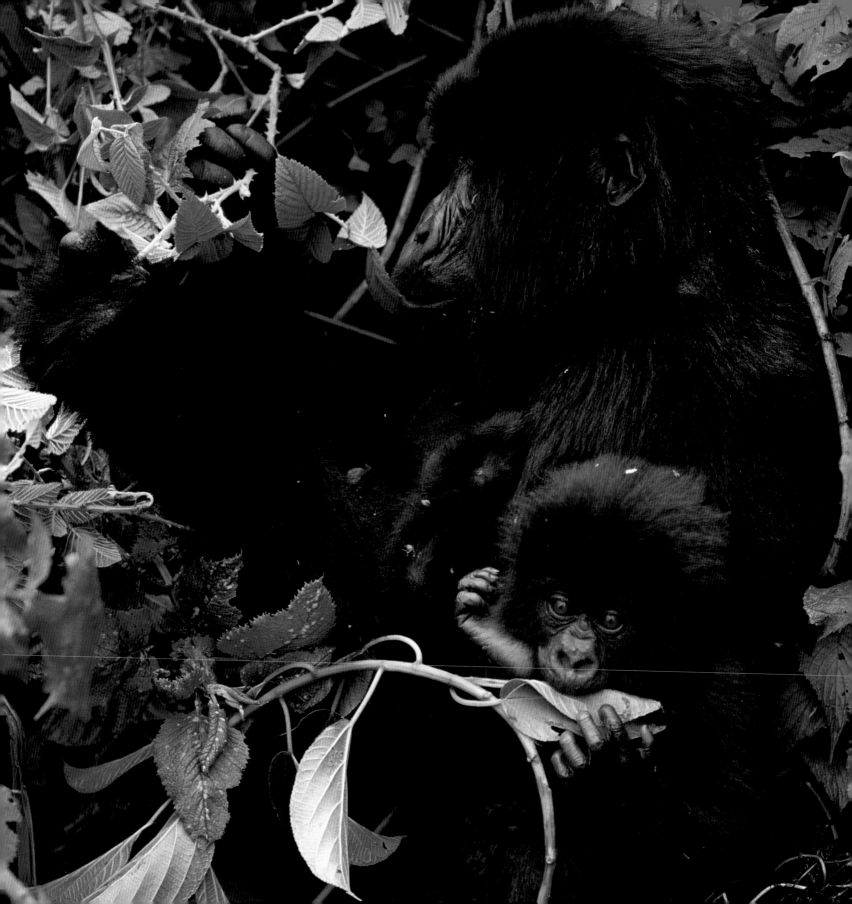

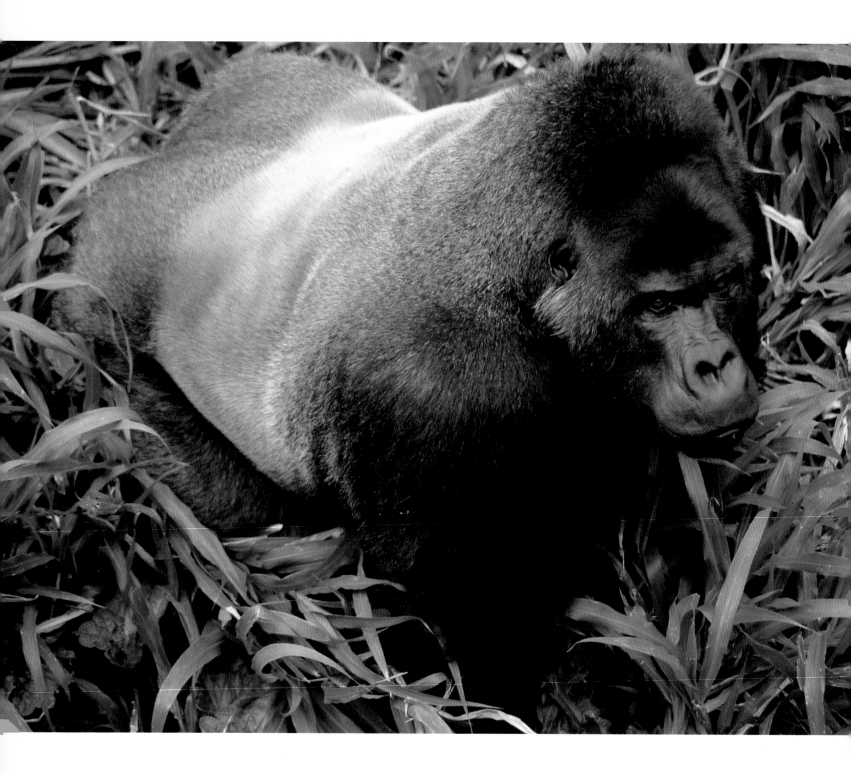

tall and their arms span almost 3 meters (10 feet). They are robust animals with powerful upper-body strength. Adult females typically weigh the same as an adult human male, about 75 kilograms (165 pounds), and males tip the scales at twice as much. Eastern lowland gorillas have the heaviest males, averaging 165 kilograms (363 pounds), whereas males of the smallest subspecies, the western lowland gorilla, still average 140 kilograms (308 pounds).

Although size is a good way to recognize gorillas, so too are their faces. Gorillas often appear to stare inquisitively because of their small eyes, prominent brow, and very short muzzle. It is by observing this muzzle, with its flared nostrils and wrinkles, that people can identify individuals; gorilla "nose-print" patterns are as unique as fingerprints. Gorillas are also recognizable by their hairless faces, ears, hands, and feet, and in males, by their bare chest and pot bellies. Both sexes' canine teeth are large and sharp. Although both mountain and eastern lowland gorillas have jet-black skin and hair, the smaller western lowland gorillas' coat is grayer with reddish tints. Adapted for their 3000-meter (9900-foot) home in the montane rain forest, mountain gorillas have long, thick coats, whereas the lowland subspecies have short hair and thinner coats.

Mature males have a highly distinctive coat. At around fifteen years of age, the hair on a male's back gradually changes from black to silver—and he becomes known as a silverback instead of a blackback. On mountain and eastern lowland gorillas, a saddle of light-colored, silvery hairs forms between the shoulders and the rump, whereas western lowland gorillas' larger, silver patch reaches to the thighs and blends in with the surrounding hair. Older males also develop a dense pad of connective tissue and a bony ridge on their crowns, giving them distinctly cone-shaped heads.

Gorillas walk on all fours when on the ground, and adults rarely climb high into the trees. However, even 200-kilogram (440-pound) males sometimes climb

ALTHOUGH BOTH MOUNTAIN AND EASTERN LOWLAND GORILLAS HAVE JET-BLACK SKIN AND HAIR, THE SMALLER WESTERN LOWLAND GORILLAS' COAT IS GRAYER WITH REDDISH TINTS.

more than 30 meters (100 feet) to feed. Females and young gorillas scale trees more frequently, but even they are not especially agile.

## Gangly Chimpanzees

Chimpanzees are found across twenty-one African nations in tropical rain forests, woodlands, and savannas, from Tanzania to Guinea. A few parts of their range overlap with that of gorillas. Although chimpanzees' territory was once unbroken, humans have fragmented it. Sadly, the name common chimpanzees, which is sometimes used to describe these animals, is now a misnomer.

There are three subspecies of chimpanzees. The pale-faced, or western, chimpanzee (*Pan troglodytes verus*) separated from other chimpanzees more than 1.5 million years ago. The other two subspecies, the black-faced, or central, chimpanzee (*Pan troglodytes troglodytes*), and the eastern, or long-haired, chimpanzee (*Pan troglodytes schweinfurthii*) diverged from each other more recently, approximately 440,000 years ago.

Chimpanzees stand 1.0–1.7 meters (3.3–5.6 feet) tall, and their arms spread 2.5 meters (8.25 feet) or more. In the wild, males weigh on average 40 kilograms (88 pounds) with a range of 34–70 kilograms (75–154 pounds), and females are closer to 30 kilograms (66 pounds) with a span of 26–50 kilograms (57–110 pounds). Central chimpanzees are usually the largest and eastern chimpanzees the smallest subspecies, although diet may have more to do with size than genetics. In captivity, chimpanzees may weigh twice as much as in the wild because of poor diet and lack of exercise.

Male chimpanzees have large canine teeth that are absent in females. Except for a few larger animals with a bony, skull-top sagittal crest, all chimpanzees' heads are round. Their ears and lips are prominent and their limbs long, slender, and gangly looking. When they stand, their hands hang below their knees.

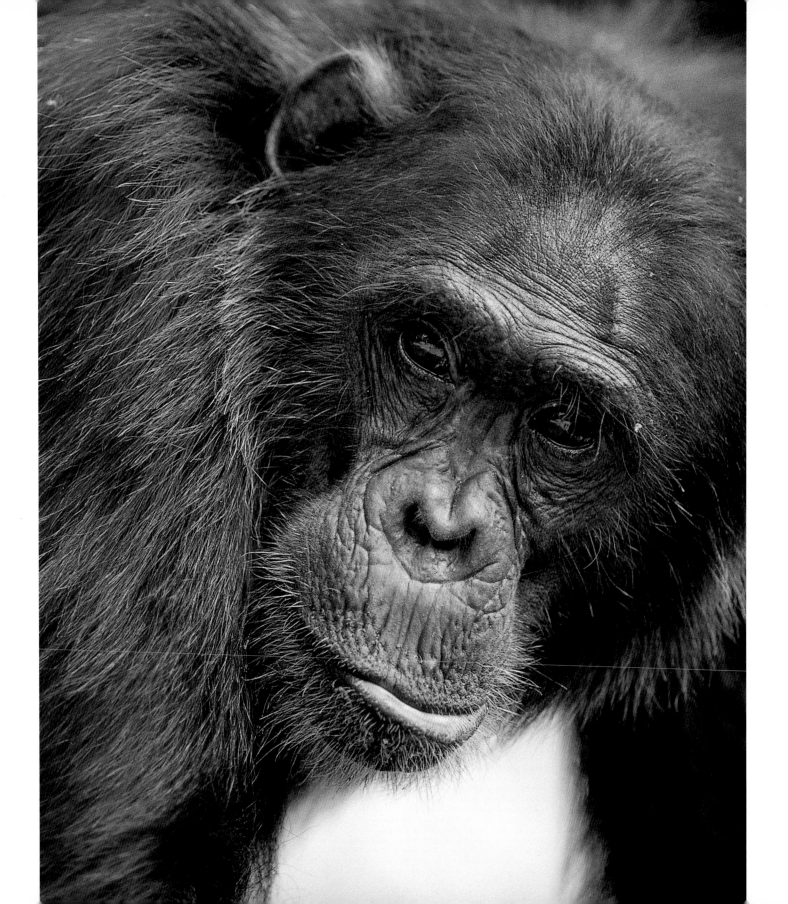

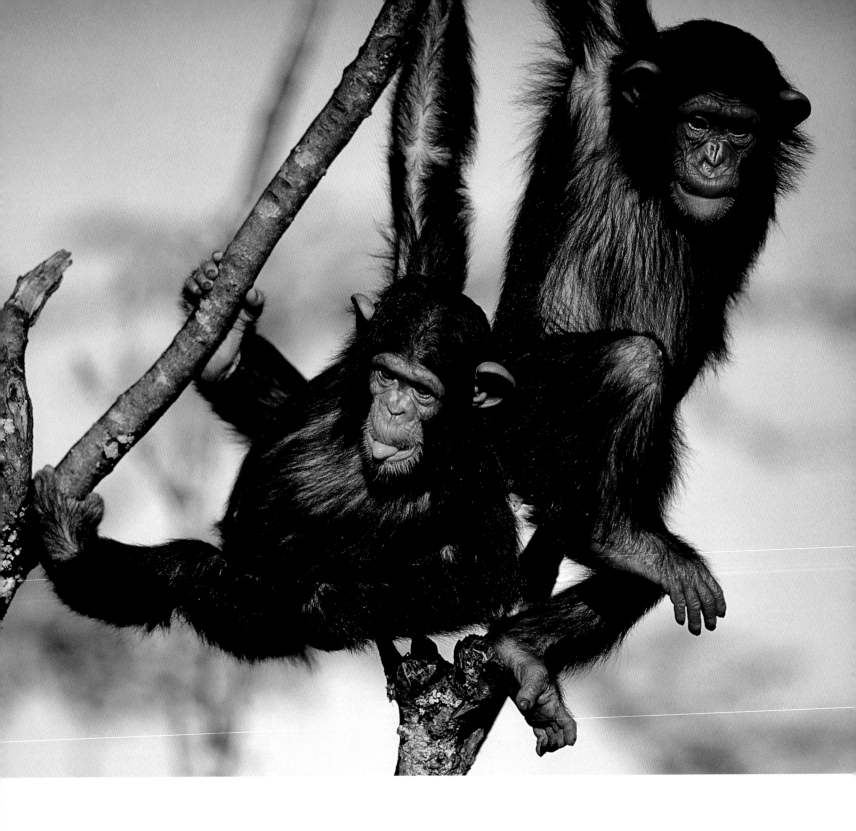

CHIMPANZEES RARELY TRAVEL FAR IN THE

TREES, BETWEEN FEEDING AND RESTING STOPS

THEY USUALLY CLIMB DOWN TO THE GROUND,

WHERE, LIKE GORILLAS,

THEY WALK ON THEIR

KNUCKLES. YOUNG CHIM-

PANZEES SOMETIMES WALK

UPRIGHT, BUT BIPEDALISM

IS NOT COMMON.

FACING PAGE

*Chimpanzees usually have flesh-coloured ears, noses, hands, and feet that darken with age. Individual chimpanzees can often be identified by their facial features, and, just like humans, family members look a lot alike, even over several generations.*

ANUP AND MANOJ SHAH

Despite common names such as pale-faced or black-faced, color is an unreliable way to tell chimpanzee subspecies apart, and these names are not widely used. All animals, regardless of sex, have skin that ranges from black to yellow, and their faces are hairless. Infants have pinkish skin and lips that darken with age. Chimpanzees' coats are typically black but may range from brown to ginger. Older animals often go gray and frequently have bald spots made worse by frequent grooming.

Although males and females do not look dramatically different, male chimpanzees are more muscular than females. Both sexes, being relatively small compared with gorillas and having grasping feet and long fingers, climb and swing in the trees more than their larger relatives. In general, juveniles and females are more arboreal than the larger males, but habitat seems to play a part. Males in the rain-forested Taï National Park, Côte d'Ivoire, where there are more trees, spend more time aloft than males in the open savanna-woodland habitats of Tanzania.

Chimpanzees rarely travel far in the trees. Between feeding and resting stops they usually climb down to the ground, where, like gorillas, they walk on their knuckles. Young chimpanzees sometimes walk upright, but bipedalism is not common. In a few cases, however, chimpanzees have been seen wandering on two feet for more than a kilometer (0.6 mile). Along with their close relatives, the bonobos, chimpanzees are the most human looking of animals.

## Gracile Bonobos

Bonobos live in the lowland, mainly primary, tropical rain forests of Congo/Zaire between the Congo, Kasai, and Lualaba Rivers. Their range does not overlap with that of any of the three chimpanzee subspecies; it covers just 350,000 square kilometers (140,000 square miles), an area slightly smaller than Germany.

In 1923, scientists first identified a new subspecies of chimpanzee, which they

called pygmy chimpanzees. However, that first observation was actually of a juvenile bonobo, and before long, scientists realized that these animals were a distinct species. The name bonobo may actually be a misspelling of "Bolobo," a town in Congo/Zaire.

Adult bonobos are about the same size as (or even larger than) eastern chimpanzees—male bonobos weigh, on average, 45 kilograms (100 pounds) with a range of 37–61 kilograms (81–134 pounds), and females weigh, on average, 33 kilograms (73 pounds) with a span of 27–38 kilograms (59–84 pounds). In height, bonobos compare with the smaller end of the chimpanzee spectrum.

Bonobos have a slighter build than chimpanzees and, combined with their remarkably long legs and small heads, this small build gives the illusion of a small stature. These features suggest that bonobos are neotenic, meaning that adults keep juvenile characteristics as they mature. Other apparently juvenile features retained by adult bonobos include a white-tail tuft that disappears in chimpanzees just after weaning, shrill calls that sound like those of juvenile chimpanzees, and a vulva that is positioned towards the front rather than the rear. However, whether bonobos or chimpanzees more closely resemble their common ancestor is not known.

Perhaps partly because of their juvenile traits, male and female bonobos are not very visibly different from each other, although males do have large canines. Both sexes' heads are rounder, their muzzles flatter, and their ears smaller than those of chimpanzees. Bonobos also have jet-black hands and faces but pink lips. Their black hair naturally parts in the middle, almost like a human hairstyle.

The bonobos' delicate, gracile build may explain why they climb and leap among the trees with such great agility, spending so much of their time aloft compared with chimpanzees. When they are on the ground, bonobos often walk on two legs, especially when carrying food. No one can look at such animals without considering them close relatives.

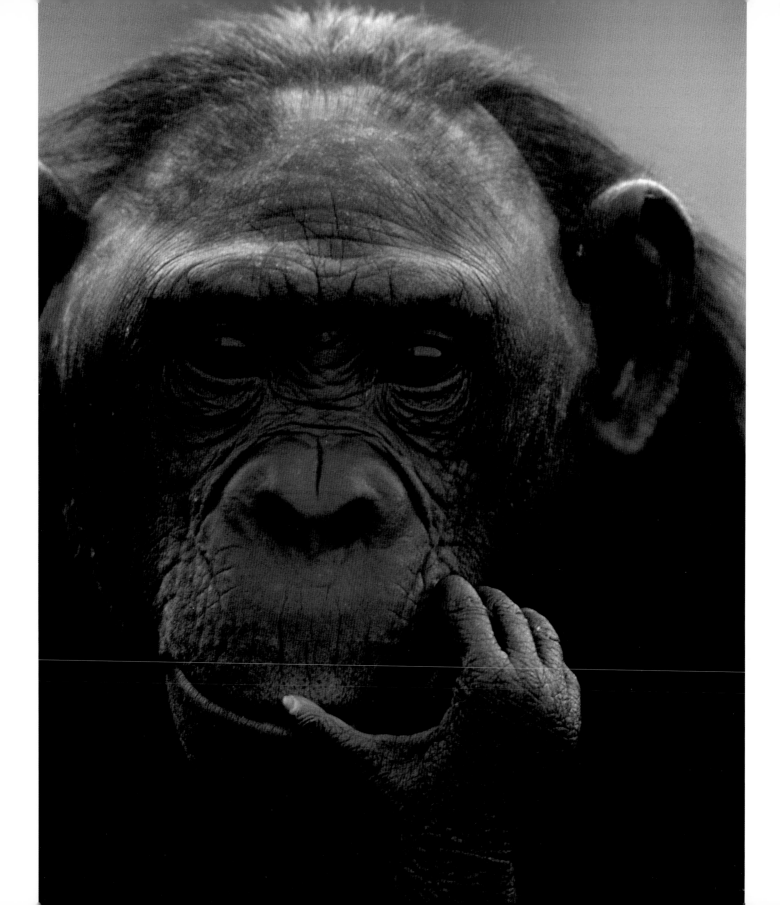

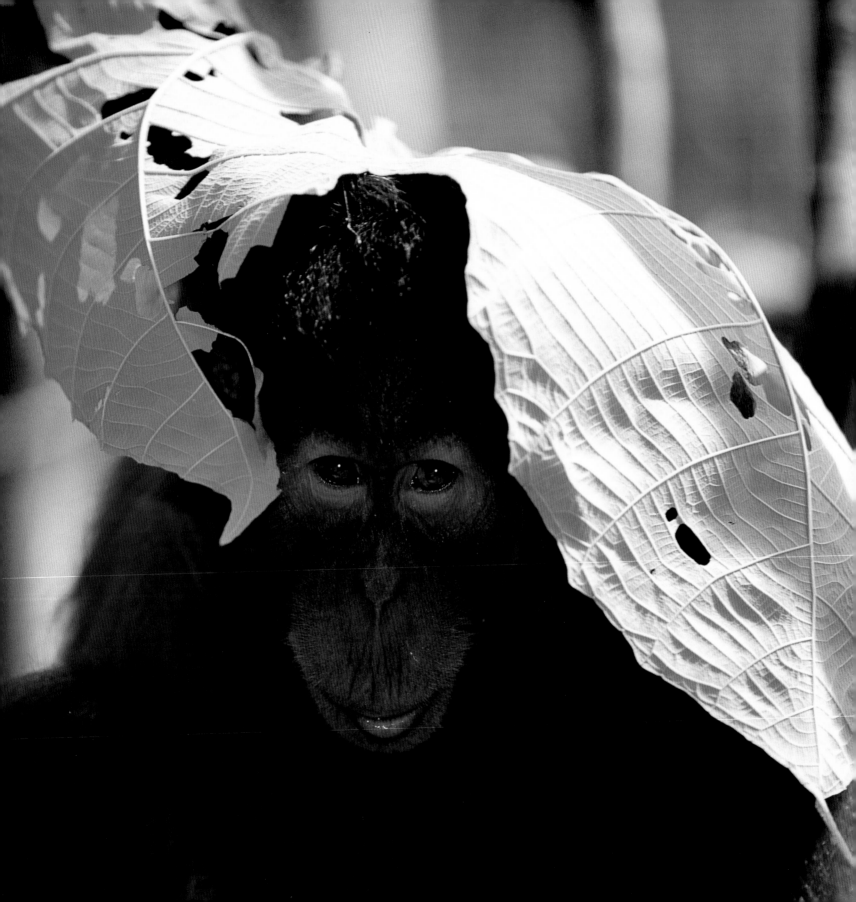

# GREAT APE SOCIETY

*Chapter Two*

Imagine a world in which finding enough suitable food, escaping predators, avoiding or eliminating parasites, dealing with bad weather, finding a mate, and raising offspring to adulthood were everyday concerns. This is the world faced by animals around the globe. Many animals solve these problems alone. They forage alone, deal with predators alone, and unite with a mate only when it is time to breed. Others band together in groups. Group living may simply involve a herd of animals traveling together, taking advantage of greater numbers to reduce the risk of predation, or it may involve extended families in which animals cooperate within a more complex society. Among the great apes, evolution has borne both loners and society-dwellers.

## THE FAMILY APE

Great apes usually live within defined residential ranges that vary in size. Female orangutans may range over less than 1 square kilometer (0.4 square mile), whereas gorilla, bonobo, or forest-dwelling chimpanzee groups may occupy more than 40 square kilometers (16 square miles). In the savanna, chimpanzees often roam over territories of more than 500 square kilometers (200 square miles). The size of an animal's range is determined by the type of habitat, the amount of available food, the number of breedable mates, and the intensity of competition with apes from neighboring territories.

Within most ranges, males dominate females (the exception being bonobos),

and within the established social hierarchy, males and sometimes females compete with each other for food and mates. Dominant males can lead a group for many years. Under this system, the dominant male fathers the majority of the group's offspring and so, in many ape societies, female choice of a mate has evolved to reduce inbreeding. Among the African apes, most females transfer from their birth group into a new family before they breed for the first time.

The great apes are tropical animals, and their daily lives are dictated by the diurnal cycle that splits the day into equal parts light and dark. For most, the day begins at dawn, 6:30 A.M. As much as half the day may be spent foraging. Early morning feeding is often interrupted by a period of midday rest, to be followed by more foraging in the afternoon, and perhaps some traveling to a new foraging area. In the early evening, the apes build nests from branches and leaves, breaking sticks and padding their nests with soft leaves and moss. Dependent youngsters sleep in their mothers' nest, whereas those that are weaned learn by imitation and practice how to build their own. A new nest is constructed every night, and apes retire as dusk plunges the forest into darkness.

## Lone Orangutans

The rain forest seems so lush and full of life that it is hard to imagine orangutans not having enough food. But the fruit they eat, such as figs, is widely dispersed, and patches of food large enough for several orangutans to share are rare. As a result, orangutans usually forage alone. Also, since most of the predators in southeast Asian rain forests live on the ground, and orangutans need fear only the occasional large eagle, they do not need to live in groups for protection. Lone adult males, adult females with dependent offspring, and solitary subadults that have not yet fully matured make up the orangutan population. This arrangement can make it difficult for males to find a receptive female when it is time to breed.

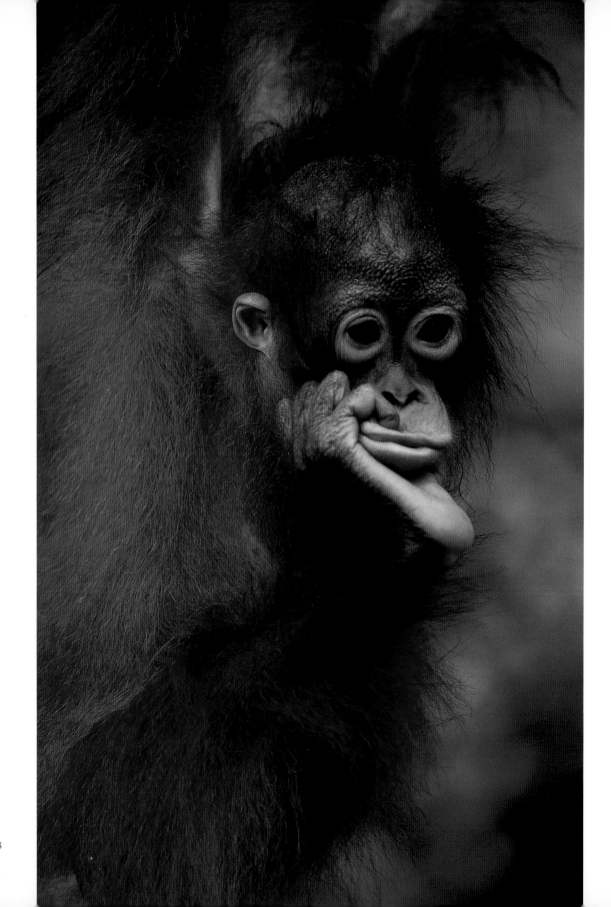

YOUNG FEMALES LEAVE

THEIR MOTHERS AT AGE

SIX OR SEVEN AND MAY

SETTLE IN A RANGE

NEARBY, BUT YOUNG

MALES BECOME NOMADIC.

In ideal conditions, undisturbed rain forest habitats can support between two and five orangutans per square kilometer (0.4 square mile). Orangutans live in large, overlapping home ranges, but only males defend their domain from other adult male interlopers. A male's 2–6-square-kilometer (0.8–2.4-square-mile) range often encompasses several female territories, and he may journey several kilometers a day in search of a sexually receptive female. Because orangutan infants depend on their mother for four years, and females average seven-year birth intervals, finding a willing female mate is not easy.

Female orangutans largely tolerate other females whose ranges they overlap. Although they do not group permanently, females sometimes feed in the same tree and may socialize with each other; they may travel together for several days. Subadult animals may congregate for short periods. In general, Sumatran orangutans socialize more, and over a longer period of time, than their Bornean counterparts. Adolescent females are the most sociable orangutans; they groom each other and even approach adult males to groom them. However, once they become pregnant, females keep much more to themselves and, once they deliver, mothers spend all their time with their infant.

Young females leave their mothers at age six or seven and may settle in a range nearby, but young males become nomadic. Subadult males without their own range defer to resident adult males and cannot easily meet females. It may be years before young males can keep their own territory because they must either defeat a dominant male or inherit a dead male's range.

## Patriarchal Gorillas

Gorillas live in extended families that average five to ten members but range from as few as two to as many as thirty-six animals. All groups center on at least one, but often several, mature males, the silverbacks. If a group has more than one

WHEN A MOUNTAIN

GORILLA GROUP MEETS

ANOTHER GROUP OR A

SOLITARY MALE, THE

RESIDENT SILVERBACK

BEATS HIS CHEST, BREAKS

BRANCHES, AND CHARGES

TO SHOW OFF HIS

STRENGTH TO BOTH

HIS FEMALES AND THE

INTRUDING MALE.

male, they are typically related, usually a father and his son(s), or half brothers. The dominant silverback controls everything that the group does, from traveling to feeding and sleeping. He also protects the group and can rule for more than ten years.

Other family members include young blackback males that leave the group by age fifteen unless there is a chance of succeeding the silverback, adult females with unweaned youngsters, and younger, unbred females that emigrate at about age ten. Whereas females always transfer to either a lone male or another group, young males may wander alone for years before they attract females away from existing groups. At any one time, about 10 percent of gorillas are solitary males, although sometimes they even band together to form all-male groups.

Silverbacks do not defend their territories, which average 8 square kilometers (3.2 square miles) but can reach 40–50 square kilometers (16–20 square miles). However, they do actively safeguard their family from predators and outside foreign males that try to steal females or take over the group.

Silverbacks and their group's females have a very close relationship that begins during female transfer. Males cannot force potential mates to join them, and females carefully observe a silverback before choosing to migrate to him or to his group. Females can gauge a male's strength and ability to protect them by watching how he deals with other males that he encounters, beginning with the females' own father in her natal group. A male that is regularly defeated by others cannot hope to attract females. Females clearly prefer males that can protect them and their young; they tend to select older, experienced silverbacks over younger animals.

When a mountain gorilla group meets another group or a solitary male, the resident silverback beats his chest, breaks branches, and charges to show off his strength to both his females and the intruding male. Almost half of these contests

FACING PAGE
*This mountain gorilla
silverback, Titus, is
the protector of his group.
If the family unit is
threatened, he will roar
loudly, gathering the
females and their offspring
safely behind him, and if
the threat continues, he
may beat his chest and/or
charge at his adversary,
breaking branches as he
does so.* MICHAEL
NICHOLS/NGS IMAGE
COLLECTION

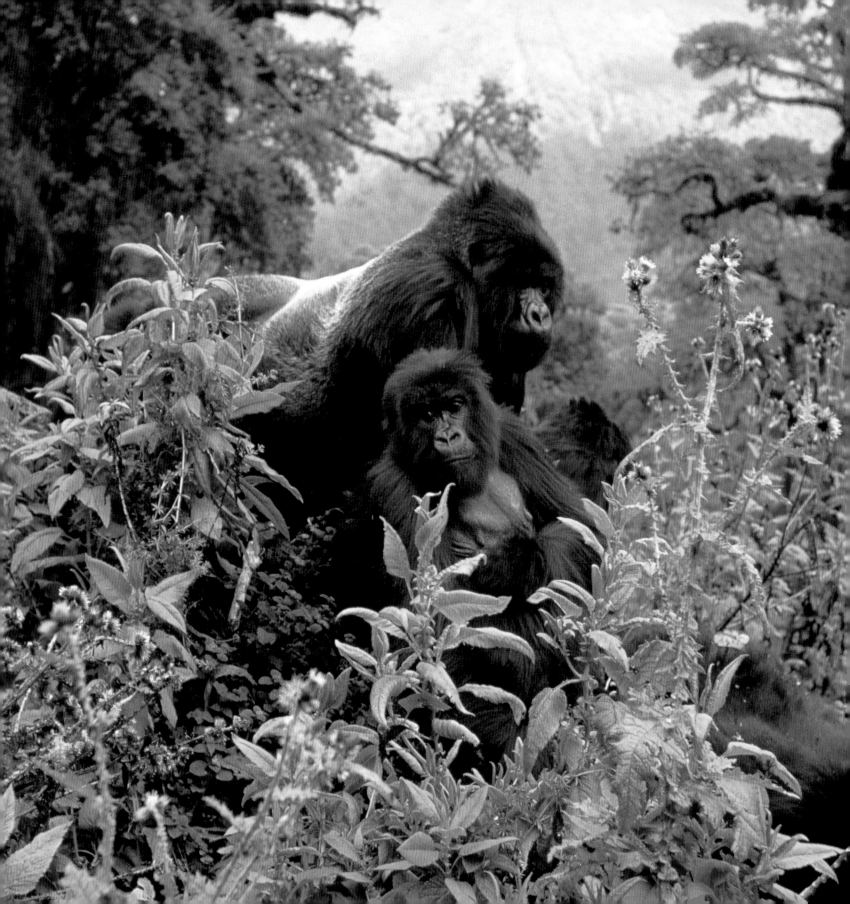

escalate from displays to physical fights; the more sexually receptive females the silverback is shielding, the more intense his aggression. More than 75 percent of mountain gorilla silverbacks show signs of head wounds, and even more are missing canine teeth, probably from fighting.

Females do not join in these confrontations, but they watch carefully. If the rival overpowers their silverback and takes over the group, he kills any dependent offspring so that the females are ready to breed again. However, more usually, infanticide occurs when females transfer to a new group following the death of their own silverback from natural causes, poaching, or predation. During a fifteen-year period at Virunga, 38 percent of infant deaths were due to infanticide.

Although females never intervene in conflicts between males from rival groups, they often do so in conflicts between two related males in their own group, blocking charges or even grabbing hold of one of the males until the attack ceases. It is in the females' best interest to keep the peace among multiple males in their group, because more males mean more protection for themselves and for their infants.

Once females establish themselves in a group, they groom males preferentially and sit and forage closer to the silverback than to any other adult. Since females move to a new group when they mature, they are usually without close relatives—choosing a male and transferring to him outweigh the benefits of staying with mothers, sisters, or aunts. Occasionally, related females migrate together; when that happens they groom each other frequently and ally during fights over food with other, unrelated animals. Only rarely do unrelated females form such alliances.

When they do form, female alliances are frequently compromised by the silverback. Conflicts between resident females and new arrivals threaten group stability. Since he attracted the females to his family, the patriarch intervenes to

prevent resident females from ganging up on the immigrants and potentially driving them from the group. Females may leave their adopted family if there is too much competition with other females or if they no longer feel protected by the silverback. In the Virunga Mountains, in three of the four cases when a dominant male silverback died leaving a younger silverback or a silvering blackback, the females emigrated to an older male rather than staying with the more inexperienced successor.

## Competitive Chimpanzees

Between fifteen and more than a hundred chimpanzees may live in a community. Within the community, smaller parties regularly form and disband around activities such as mating or feeding. Membership in these parties is highly flexible and fluid, so this social structure has become known as "fusion-fission." At the research site in Gombe, Tanzania, four to five chimpanzees make up parties that meet for an average of just seventeen minutes, although the groupings can last for several days. Ranging in size from 12 square kilometers (4.8 square miles) in forests and woodlands to more than ten times that area in the less productive open savanna, communities are the foundation of chimpanzee social life.

Chimpanzee communities consist of related males and, usually, unrelated females with their offspring. Generally females outnumber males within the territory, but the males dominate in social situations. An alpha male, the top-ranking male chimpanzee that defeats other males to win his rank, leads every community. To secure his position, the alpha male allies with lower-ranking males; he will not stay in charge unless others in the group support him.

Males test their position in the group's hierarchy by displaying and often by fighting with each other. For chimpanzees, moving up the chain of command, or remaining at the top, often depends more on their social relationships than on

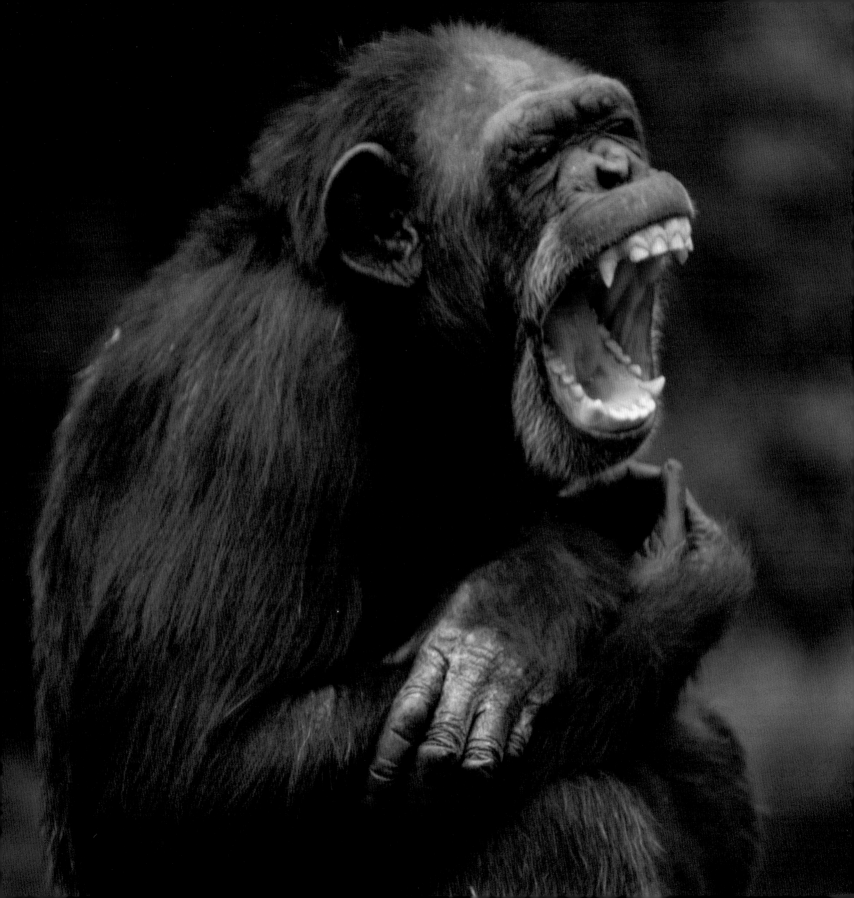

FEMALES MUST STAY IN THEIR COMMUNITY

RANGE UNLESS THEY ARE IN ESTRUS. NON-

BREEDING FEMALES RISK BEING ATTACKED AND

KILLED BY OUTSIDE MALES

IF THEY LEAVE THEIR

RANGE, BUT FEMALES

THAT ARE OVULATING OR

CLOSE TO OVULATING

CAN TRANSFER FROM ONE

GROUP TO ANOTHER

WITHOUT DANGER.

FACING PAGE

*Chimpanzees' facial expressions convey their moods to others in the group. A higher-ranking chimpanzee may confront a lower-ranking animal by using an open-mouth threat. In response, a lower-ranking chimpanzee may grin with its mouth closed to show that it is not threatening the other's position.* ERWIN AND PEGGY BAUER

their physical strength. Males usually gain their power from their close male relatives, but they constantly ally with different males to try and best their rivals. Grooming, sharing meat, hugging, and kissing between males strengthens these alliances.

Only about 1 percent of conflicts between males turn truly violent, and males usually reconcile after an altercation. Males kiss each other ten times more often immediately after a conflict than at any other time. Males also groom each other four times more often than females, and are twenty times more liable to pant-grunt, kiss, and embrace than females.

Adult males also cooperate to guard their range against predators, such as lions or leopards, and to prevent attacks by males from other chimpanzee communities. Conflicts with neighboring communities can sometimes approach all-out warfare. At Gombe, an estimated 25 percent of all adult male deaths occur during fights with foreign males that encroach upon their territory or during raids on another community's territory.

Females must stay in their community range unless they are in estrus. Non-breeding females risk being attacked and killed by outside males if they leave their range, but females that are ovulating or close to ovulating—a condition made obvious by their brightly swollen genitals—can transfer from one group to another without danger. Adult males can never safely move between groups. If a male leaves his community, is exiled by other males, or outlives his group, he must live alone for the rest of his life.

Unlike males, females rarely socialize with other adults unless they are related. Mothers and daughters preferentially groom each other and ally in disputes with others, at least until the daughter transfers to a new group.

When estrous females join a new community, resident females largely ignore them. However, residents can become openly hostile and physically attack

newcomers. This aggression may be related to attempts by resident females to protect their core feeding areas from competitors. In these skirmishes, males often intervene to protect the disadvantaged immigrants.

Although most chimpanzee communities are made up of bonded males and competitive females, chimpanzees in Bossou, Guinea, and Taï, Côte d'Ivoire, seem to have a more egalitarian society. Males at Bossou groom each other less than chimpanzees from East Africa, whereas females at both locations develop friendships and even form all-female coalitions. At Bossou, where there are few neighboring communities to transfer to, females are able to form long-term relationships with their own relatives throughout their lives. It may be that the highly productive rain forest also reduces competition between animals, allowing closer associations between females and also reducing the need for cooperative, defensive alliances between males.

## Harmonious Bonobos

Bonobos live in "fusion-fission" societies that superficially resemble chimpanzee communities. Between 50 and 120 bonobos roam over a 22–68-square-kilometer (8.8–27.2-square-mile) range. As with chimpanzees, small, ever-changing groups make up the larger community. Between two and ten bonobos, of both sexes, usually form a party that is of variable duration.

Unlike chimpanzees, male bonobos gain status and potential mates by spending most of their time with females rather than grouping with other males. Especially important is a male's own mother, from whom he is rarely parted for more than a day. A male is unlikely to become an alpha male if his mother is dead or otherwise absent, but the son of a high-ranking female can even outrank older males in the community. By staying close to his mother, a male bonobo is able to form bonds with his mother's female associates, increasing his mating opportunities.

FACING PAGE

*Bonobo communities are distinctly matriarchal. Unlike chimpanzees, female bonobos form close friendships with each other, and males spend more time with females— especially their mothers— than other males. For these young male infants, their future status will depend on their mother's rank.*

ART WOLFE

As with chimpanzees, female bonobos join a new group at adolescence, whereas males stay in the group where they were born. However, even without close relatives, new females are still able to form strong associations with resident females.

When a female joins a new group, she selects a resident female and bonds with her by grooming and performing a distinctly sexual act known as genitogenital rubbing, during which the females position themselves face-to-face and rub their genitals together. Sex eases immigrants' entry into the community, and rarely do resident females attack them. Since females do not usually disperse into small groups or range alone, residents must accept immigrants if the community is to survive. Females may also use sex to trade for food, with one animal offering sex for a share of the food in the possession of the other.

Male bonobos compete much less than chimpanzees and are far less aggressive. Although males frequently vocalize and gesture at each other and even drag branches, violent physical attacks are rare. Male bonobos' minor tantrums pale beside the occasionally homicidal fury of chimpanzees. To reconcile after an altercation over food or to appease a more dominant individual, male bonobos may even rub their rumps together as they stand facing away from each other.

Bonobos have never been seen killing their own infants, and rarely do they fight with neighboring communities. There have even been observations of bordering communities mingling, grooming each other, playing, and even engaging in sexual contact, all without any physical aggression. Such associations are unheard of among chimpanzees. Compared with the societies of other apes, bonobo society seems positively utopian.

The drive to reproduce is the strongest in the animal kingdom, and it pervades every aspect of an animal's social life. Among the great apes, sex is about reproduction, status, and social bonding. Each of the great apes achieves its goals in a slightly different manner, but the ultimate goal is the same for each species: to pass along its genes to the next generation.

### Harassed Orangutans?

Orangutans do not usually associate with each other except when it is time to mate. Both males and females reach sexual maturity at around age seven, but females do not usually conceive for at least another five years. This delay, called adolescent sterility, probably ensures that the females are strong and mature enough to carry their offspring for the full eight-month term. Most males do not breed until they are at least thirteen or even fifteen years old. As subadults, males pursue females and are often able to force matings, but they are not usually able to outmaneuver fully grown males that associate with the females when they are most likely to conceive. Given the choice, females mate with mature adult males that have already proven their genetic vigor by defeating other males and siring healthy infants.

Because female orangutans have such a long interval between births—up to seven years in some cases—few are sexually receptive in any one year. As a

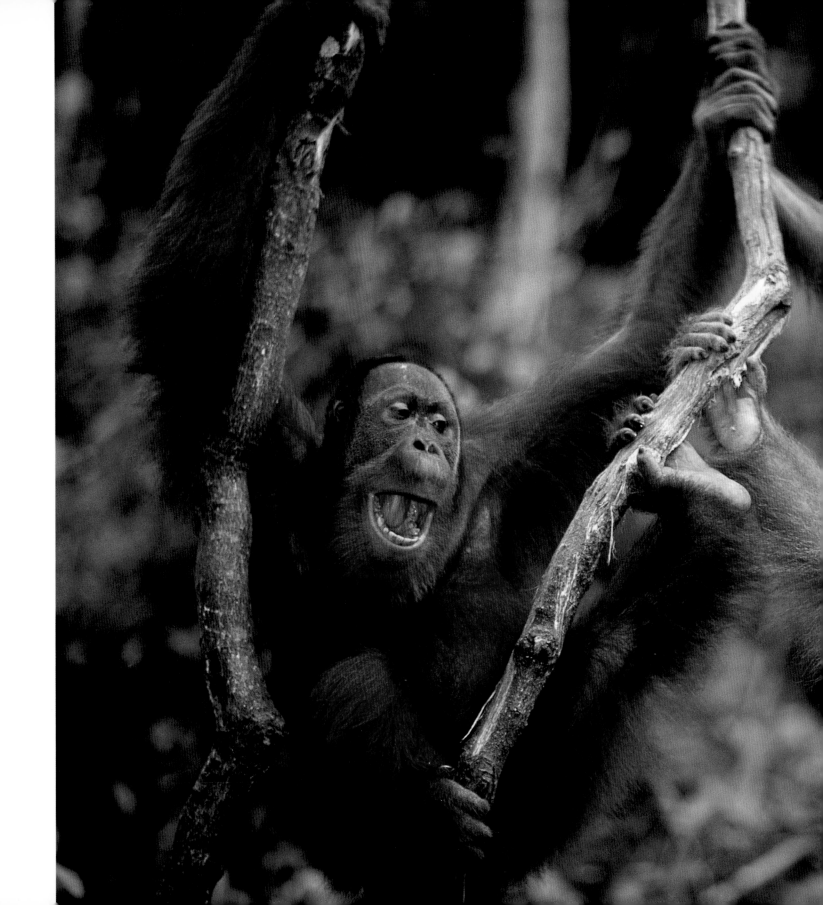

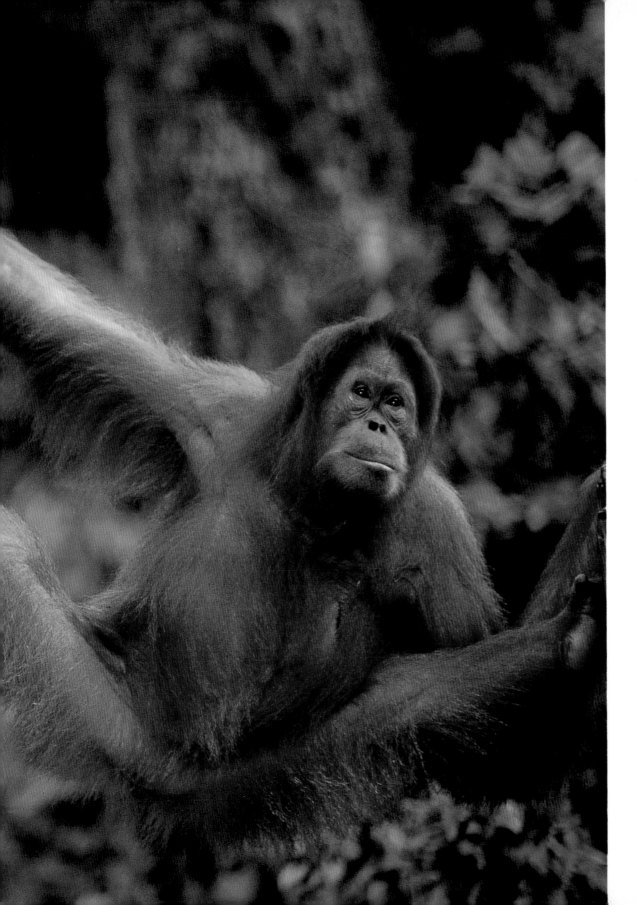

Female orangutans prefer to mate with mature adult males (identifiable by their broad flanges). Subadult males, such as the one on the left, are usually ineffective at breeding. Although they may be able to approach a female and even mate with her, she generally conceives with a dominant male that has previously fathered offspring.

ANUP AND MANOJ SHAH

41

DURING THEIR MOST FERTILE PERIOD, FEMALES

USUALLY CHOOSE TO CONSORT WITH MATURE

MALES, EVEN IF SUBADULT MALES ARE ABLE

TO FORCIBLY MATE WITH

A FEMALE AT OTHER TIMES

OF THE MONTH, IT IS

UNLIKELY THAT THEY

ARE ABLE TO FERTILIZE

THEIR CONQUESTS, MOST

OFFSPRING ARE THERE-

FORE FATHERED BY

ADULT MALES.

result, males compete rigorously for access to those females. Mature males are usually able to keep subadults at bay with their blustering displays and lion-like long calls. Rare encounters between adult males can become violent, with injuries such as bites and broken fingers resulting from direct physical confrontations.

Although females are sexually receptive throughout their twenty-eight-day estrous cycle, they are most likely to conceive during a six-day window each month. Unlike many of the other apes, female orangutans do not develop a sexual swelling to advertise their condition. During their most fertile period, females usually choose to consort with mature males. Even if subadult males are able to forcibly mate with a female at other times of the month, it is unlikely that they are able to fertilize their conquests. Most offspring are therefore fathered by adult males. Whereas Bornean males tend to depart soon after mating, in Sumatra males form longer consortships with their mates, remaining until the infant is born. With predators such as tigers (*Panthera tigris*) more prevalent on Sumatra, long associations between males and females may have evolved as a protective strategy.

## Gallant Gorillas

Mountain gorillas are the best known of the gorilla subspecies, and unlike orang-utans, silverback gorillas keep their females close by, defending them, sometimes violently, against outsiders. Although females reach sexual maturity at about age eight, and males at around age ten, gorillas usually do not breed until they emigrate from their natal group, at age ten for females and age fifteen for males.

Subadult females' genitals swell during the two to three days each month that they are most likely to conceive. After females birth their first offspring, they no longer swell to advertise their fertility, presumably because they consort so closely with the silverback. If females do not become pregnant when they ovulate, they may bleed slightly.

FACING PAGE

*Most copulations among mountain gorillas are solicited by females. The actual act averages from one to two minutes, and matings take place about once every three hours while the female is in estrus.* KONRAD WOTHE/ MINDEN PICTURES

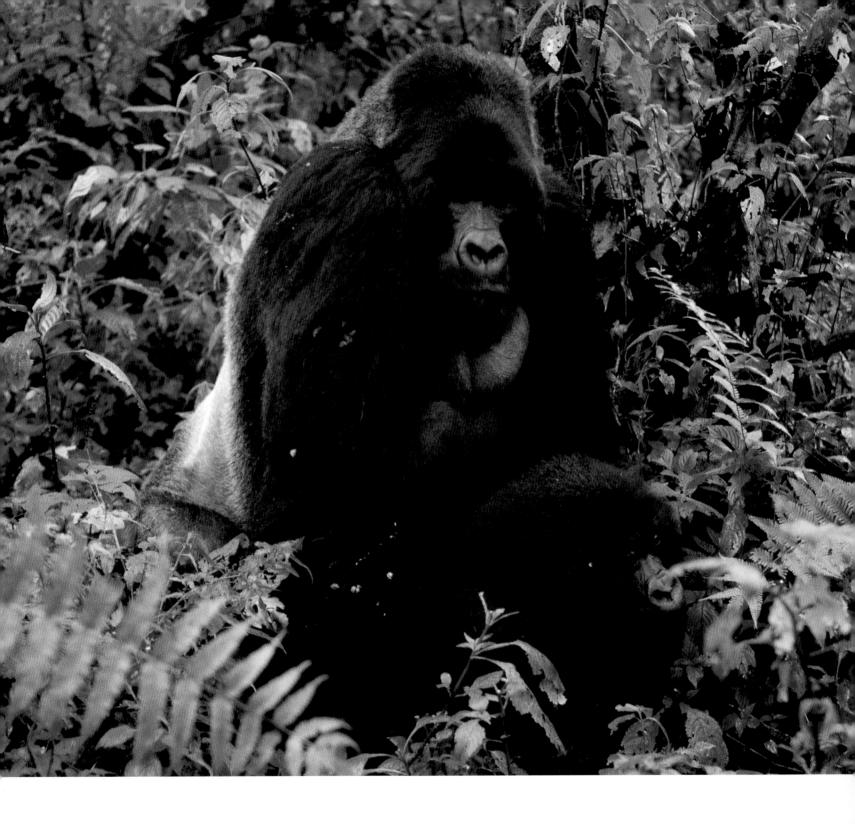

Some observers have characterized silverbacks as having a low libido, and it is often females that solicit sex from males. In some cases, silverbacks seem to initiate copulation only when they feel threatened by outside males, for example, when a solitary male approaches the group or when another group is close by. However, males do actively display by beating their chests, an action that may entice females to present for mounting. Blackback males in a group may also preferentially groom females, possibly to build a rapport with them. If the silverback dies and is succeeded by a silvering blackback or a young silverback, the heir will have a much better chance of keeping females if he has already developed a close relationship with them.

## Courting Chimpanzees

Both male and female chimpanzees mature sexually at around age seven, but females do not usually give birth until they are thirteen or fourteen. If they do not conceive after ovulating each month, females bleed menstrually. Since older animals dominate males into their mid-teens, young males rarely breed until they are at least fifteen or sixteen.

Female chimpanzees exhibit truly eye-catching bright pink or red sexual swellings when they mature. Their genitalia swell for eight to ten days every five weeks, at the time of ovulation when females are most likely to conceive. This highly visual signal advertises a female's fertility to the many surrounding males, and most mating takes place at this time. Males everywhere welcome swollen females. Only when visibly swollen can females emigrate without being attacked by foreign males. In total, females are sexually receptive for just 5 percent of their adult life.

Adult male chimpanzees are at their most competitive when there is a cycling female within their group. In large communities, where there are numerous

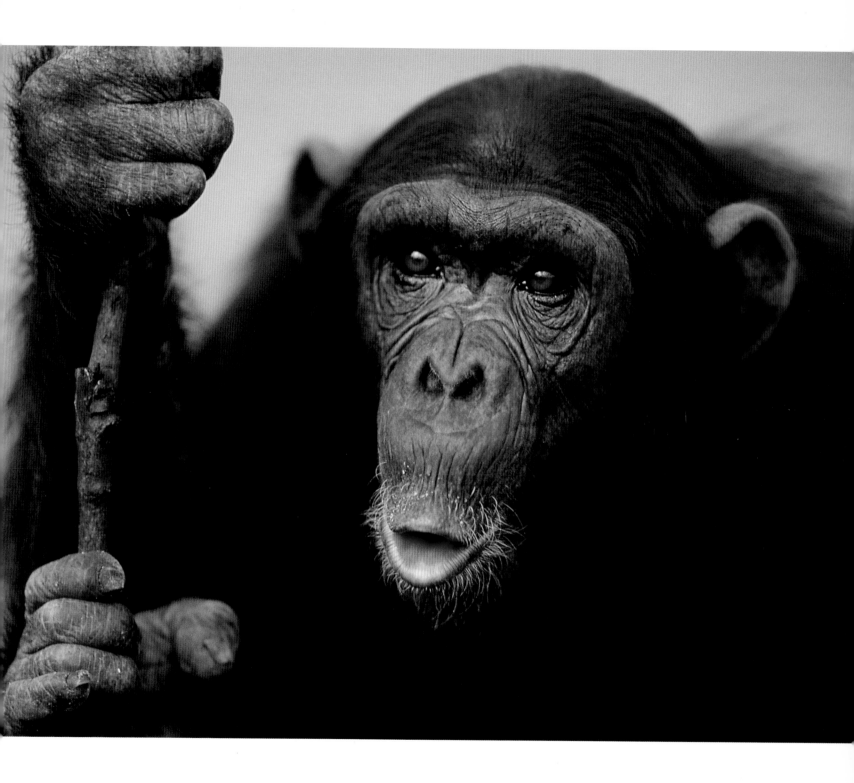

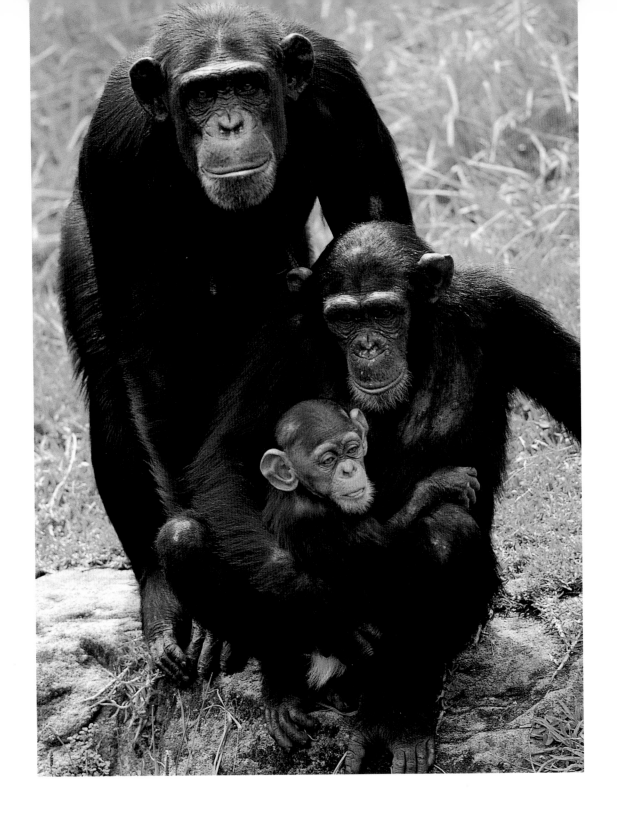

FACING PAGE

*This may look like a family scene, but chimpanzees do not live in the nuclear family familiar to humans. In chimpanzee society, females mate with multiple males. This promiscuous mating pattern reduces the risk of infanticide, since males are unlikely to kill the infant of a female with whom they have mated in the past.* ERWIN AND PEGGY BAUER

opportunities to mate and males cannot prevent others from mating, chimpanzees may copulate in full view of other males. However, some chimpanzees also form consortships. During the few days or even weeks that a consortship lasts, the pair maintains an exclusive sexual relationship. To ensure a female's cooperation and cement their bond, males often groom or share meat or other foods with her.

The alpha male chimpanzee copulates the most, performing as many as 80 percent of the matings in some communities. Alpha males, or other high-ranking males, may threaten other males to prevent them from coupling, especially as females approach ovulation—denoted by maximal swelling. Since alpha males and their allies are the most likely to mate with the female around ovulation, they sire most of the offspring. An alpha male may head a community for between three and ten years, during which time he can strongly influence the group's genetic makeup.

A promiscuous mating pattern, in which females often mate with a large number of males, may serve another useful function. With infanticide so common in chimpanzee communities, a female is less likely to lose her infant to a male if she has mated frequently with him in the past. Females that keep to the edge of a community's territory may be more likely to lose their babies to infanticide, since there is a greater probability that the babies were fathered by an outside male.

Female chimpanzees do have some choice in mating. They can accept or ignore a consort's advances, and they can transfer between communities when in estrus, especially if unrelated males are in short supply. Young females seem to prefer males that are of similar age and that they grew up with, or those that are complete strangers; they run screaming from familiar males that are old enough to be their fathers. Presumably, this reaction prevents incest.

FREQUENT SEXUAL

CONTACT EASES TENSION

BETWEEN INDIVIDUAL

BONOBOS, LETS THEM

SPEND MORE TIME

TOGETHER, AND

PROBABLY PREVENTS

MALES FROM

DOMINATING FEMALES.

## Amorous Bonobos

Bonobos have been variously described as the "free love" ape, as the ape that "makes love not war," and even as the "erotic ape." Their highly sexed nature makes them media curiosities and scientific conundrums.

Long before bonobos reach sexual maturity around age nine, they engage in numerous sexual acts with males and females in their community. Bonobos use sex to greet each other, to trade or beg for food, to reconcile after a conflict, and to ensure that altercations do not occur. There are few limits on who can couple with whom and on what they can do—bonobos perform oral sex, masturbate, and "French-kiss" with other bonobos of both sexes and in almost any age combination.

Although bonobos have more non-reproductive sexual contact than other great apes, they mate heterosexually about as often as chimpanzees. Females and males alike are most likely to have successful matings when they reach their teens. As with chimpanzees, a female bonobo's genitalia swell dramatically around ovulation to attract males. However, unlike chimpanzees, these swellings last for a much longer part of the cycle—fourteen days out of forty-five—and they do not disappear completely after ovulation has occurred. The result is that female bonobos receive males for about half of their adult lives.

Frequent sexual contact eases tension between individual bonobos, lets them spend more time together, and probably prevents males from dominating females. Since sex is freely available to all, bonobos do not have to compete aggressively for mates. And when females are sexually swollen they can take priority over males at feeding sites—even the alpha male sometimes retreats from middle- or low-ranking females.

When a male bonobo wishes to mate with a female, he often approaches her and then sits back displaying his erect pink penis. He gazes at her until she makes

*Bonobos learn about sex early in life. Infants and juveniles often try to join in with a mating couple, and sexual experimentation is a part of bonobo society. The female's sexual swelling signals that she is willing to mate; it lasts for about one-third of her monthly cycle.*

ART WOLFE

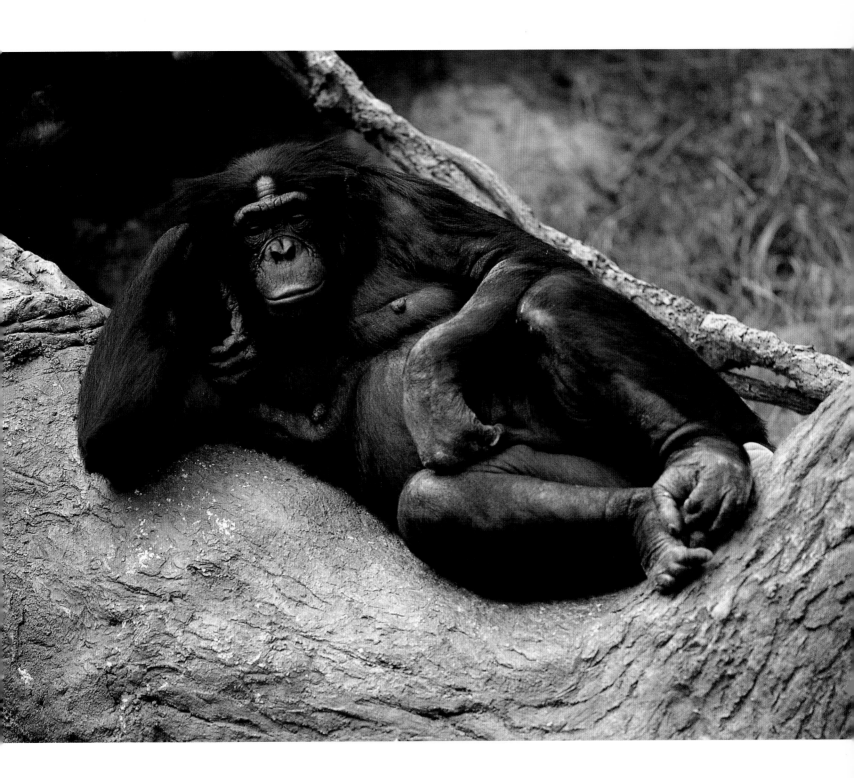

eye contact. Males initiate most successful chimpanzee couplings, but among bonobos it seems to be a more mutual decision. If the female wishes to mate, she backs up towards the male and presents to him. About three-quarters of all matings take place in this position, dorsoventrally, but a quarter of the time the female turns to face her partner and mating is ventroventral. Chimpanzees rarely copulate face-to-face, but among bonobos sex in this position may serve to strengthen the male-female bond. Even when bonobos mate dorsoventrally the female usually twists her head around to look at her mate. Intromission is brief—averaging just twelve seconds. Even so, immature and juvenile animals often watch the pair with great interest and may even try to participate.

THE BOND BETWEEN

MOTHER AND OFFSPRING

IS PROBABLY THE

STRONGEST IN NATURE,

AND THAT BETWEEN A

FEMALE APE AND HER

BABY IS LIKELY THE

CLOSEST RELATIONSHIP

SHE WILL HAVE WITH

ANOTHER ANIMAL.

## INFANT APES

Every new generation of apes begins with the vulnerability of an infant. Apes do not seem to have a distinct breeding season; they mate, and give birth, through-out the year. The bond between mother and offspring is probably the strongest in nature, and that between a female ape and her baby is likely the closest relation-ship she will have with another animal. Although she will sometimes go to her death to defend her infant from predators, at times she is helpless to stop mem-bers of her own species from killing it. She may even have to mate with the very male that robbed her of her offspring.

Infant mortality of more than 50 percent is not uncommon, due to disease, accident, starvation, lack of parental experience, or infanticide.

### Wide-Eyed Orangutans

After an average pregnancy of 245 days, female orangutans give birth to a single infant—very rarely twins. At birth, female infants weigh about 1.6 kilograms (3.4 pounds), whereas males are slightly heavier at 1.9 kilograms (4.3 pounds). Females are unaided during the birthing process, although they may be accom-panied by another dependent juvenile. Since females rarely mate while they have a highly dependent offspring in tow, the new arrival's sibling is likely to be at least four years old and probably closer to six or seven.

The newborn orangutan is all legs and arms, and its often bright red hair

frequently stands up on its head. Almost immediately after birth the infant clings to its mother's hair with an iron grip. For a full year, the young orangutan hangs on its mother's chest, suckling regularly. It has a wide-eyed innocence at this stage and rides on its mother's back until about two and a half years of age, rarely letting go. If the infant lacks a sibling, its mother is its only playmate.

A female suckles her youngster until it is about three and a half years old, although the growing orangutan may try to nurse for longer. After it is weaned, the youngster builds its own nightly nest in the trees, learning what to do by imitation and practice. However, it still stays close to its mother and independence is achieved slowly. When a new baby arrives, usually when the juvenile is between four and seven years old, there is an inevitable change in the relationship between mother and offspring as the female has a new life with which to spend her time.

A juvenile orangutan relies on its mother to protect it for a few more years, and a daughter may even settle near her mother's range. By the age of seven or eight, however, most youngsters move away to begin their own life in the rain forest. During the course of her life, a female orangutan will likely successfully raise only two or three offspring to adulthood.

## Boisterous Gorillas

Female gorillas have a reproductive life of about twenty-five years and, like orangutans, on average are able to raise only two or three offspring to adulthood. An infant weighing about 2.2 kilograms (4.8 pounds) is born following a gestation of 251–295 days, although the average is about 257 days. Twins are rare; when two babies are born together in the wild, females usually cannot raise both. Surrogate human parents usually have to raise twins born in captivity.

A newborn gorilla is a jet-black miniature of its parents. Completely helpless at birth, it clings to its mother's breast during its first six months of life and

FACING PAGE
*A seven-month-old infant orangutan clings tenaciously to its nine-year-old mother as she climbs through the Sumatran rain forest canopy. Although females are sexually mature at age seven, most do not breed until they are at least twelve. This infant, probably her first, may not survive its mother's inexperience.* ANUP SHAH/BBC NATURAL HISTORY UNIT

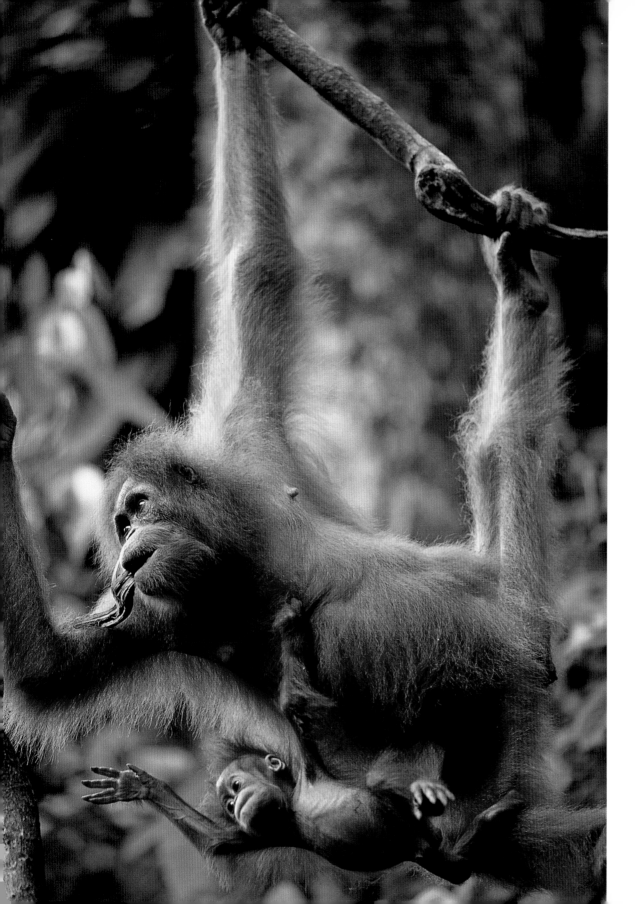

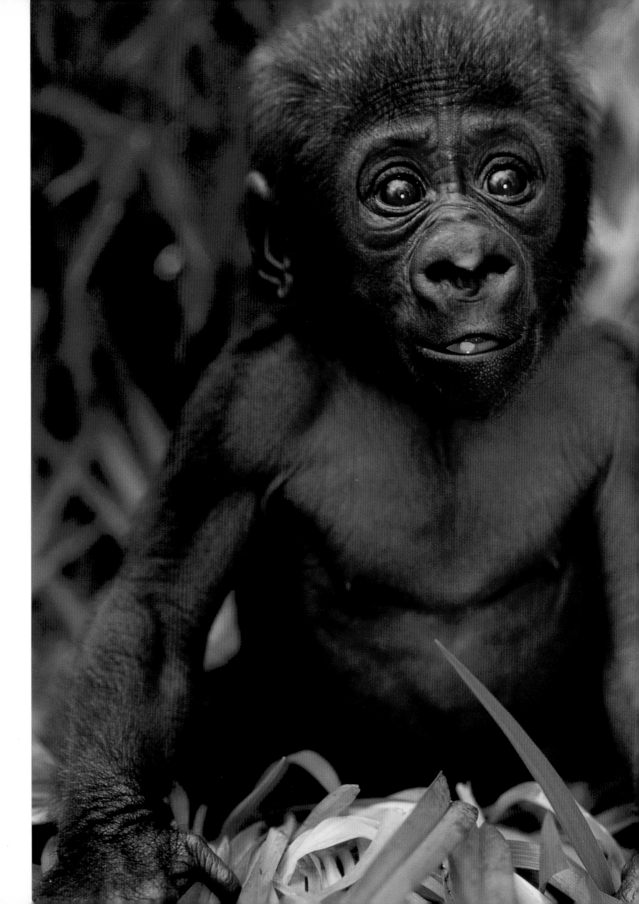

GORILLAS SUCKLE UNTIL THEY ARE THREE OR

FOUR YEARS OLD. ALTHOUGH IT HAS PICKED AT

VEGETATION FOR A WHILE, A NEWLY WEANED

ANIMAL IMITATES ITS

MOTHER TO LEARN

QUICKLY WHICH PLANTS

ARE GOOD TO EAT AS

WELL AS TO TRY OUT NEW

TASTES FOR ITSELF.

FACING PAGE

*If this tiny western lowland gorilla can survive the dangers of infancy, it may live to be fifty or sixty years old.*

ART WOLFE

suckles hourly. Even so, an infant gorilla develops much faster than a human baby. At nine weeks of age, the infant can grab sticks and plants. By fifteen weeks, the youngster is walking on all fours and, at four months, it rides on its mother's back. At six or seven months, the growing gorilla is off climbing trees.

Gorillas suckle until they are three or four years old. Although it has picked at vegetation for a while, a newly weaned animal imitates its mother to learn quickly which plants are good to eat as well as to try out new tastes for itself. Once weaned, the youngster must also begin to build its own nightly nest since it is no longer able to sleep with its mother. A female gorilla breeds again once her infant is weaned.

For a young gorilla, growing up in a secure group with other females, juveniles, and infants means ample opportunities for play; even the silverback lets young apes clamber all over him. Play teaches youngsters how to behave in the group and thus helps prepare them for the life ahead. But growing up is dangerous, and even under watchful adult eyes, as many as 42 percent or more of all gorilla infants die in their first year.

## Playful Chimpanzees

A 1.9-kilogram (4.2-pound) bouncing baby chimpanzee's arrival is a major community event. Other females clamor to hold the infant, but a new mother often keeps all but her closest female relatives at bay for the first few months. For three months, the helpless newborn suckles hourly as its mother cradles it in her arms while she sits. When the female must move, the infant grips her chest with a determination common to all of the apes.

As the young chimpanzee grows, it rides on its mother's back and sometimes stands on all fours to get a better view of its surroundings. Like a young gorilla, it plays with other youngsters, but only when the infant is old enough to venture

Infant mortality among chimpanzees can

be very high. Twenty-eight percent of

infants at Gombe, Tanzania, die during

their first year, and

40 percent die before

they are weaned.

away from its ever-watchful mother. An infant mainly plays with its older siblings, if it has any, although those without brothers and sisters seek out unrelated playmates. As a youngster grows more adventurous, around age two, its mother has much less control over it but is still its staunchest protector.

A chimpanzee is weaned when it reaches between three and a half and four and a half years of age, although some juveniles still try to suckle when they are five. Such persistence rapidly wears thin, and a female may roughly push her overgrown infant away if it tries to nurse. However, if a mother dies before her infant is successfully weaned, it will probably perish too, even if an older sibling or another female adopts it. Even after weaning, the juvenile chimpanzee still runs to its mother for comfort and protection. This relationship may last for ten years or more, especially if the juvenile is a female that stays with the group past sexual maturity.

Infant mortality among chimpanzees can be very high. Twenty-eight percent of infants at Gombe, Tanzania, die during their first year, and 40 percent die before they are weaned. Infanticide by male chimpanzees claims many of these young lives. At Mahale, Tanzania, more than 50 percent of infants die before weaning. When infanticide does occur, resident males often target immigrant mothers with infants that keep to the community's periphery. By killing a female's offspring, a male may be killing an infant that was fathered by a foreign male, and by doing so he not only eliminates a future, unrelated competitor but also brings its mother back into breeding condition. A mother that loses her infant within its first few months of life is able to give birth again within a year. If her baby survives, a female usually delivers another infant in three to six years.

FACING PAGE
*At Kenya's Sweetwaters*
*Chimpanzee Sanctuary,*
*two central, or black-*
*faced, chimpanzees play*
*with each other. The older*
*chimpanzee on the right*
*is making a play face,*
*opening its mouth without*
*showing its teeth. Play*
*teaches young animals*
*how to behave with others*
*in their community.*
ANUP AND MANOJ SHAH

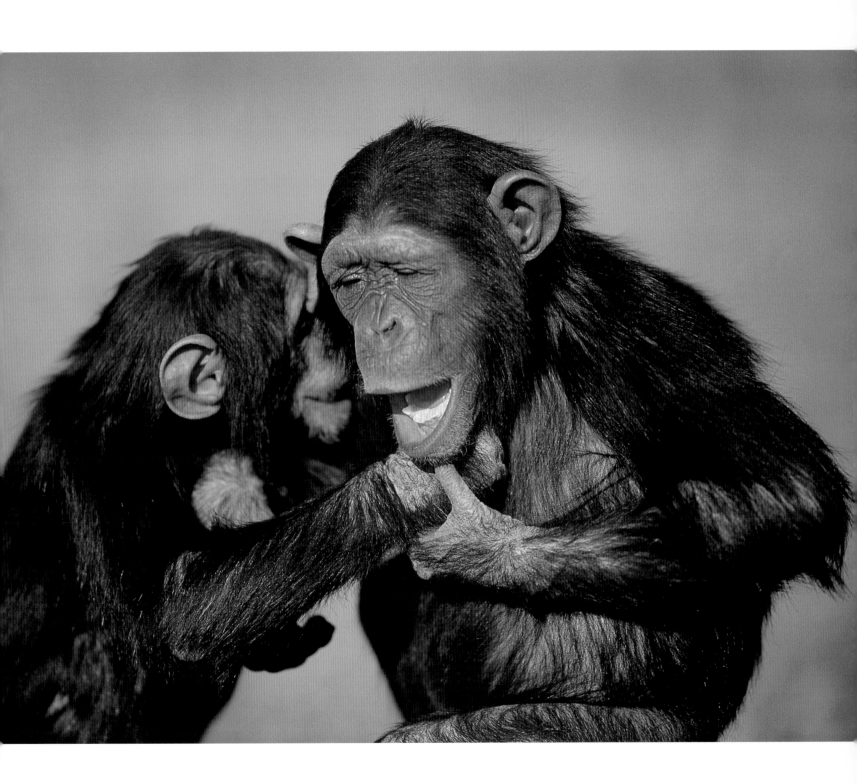

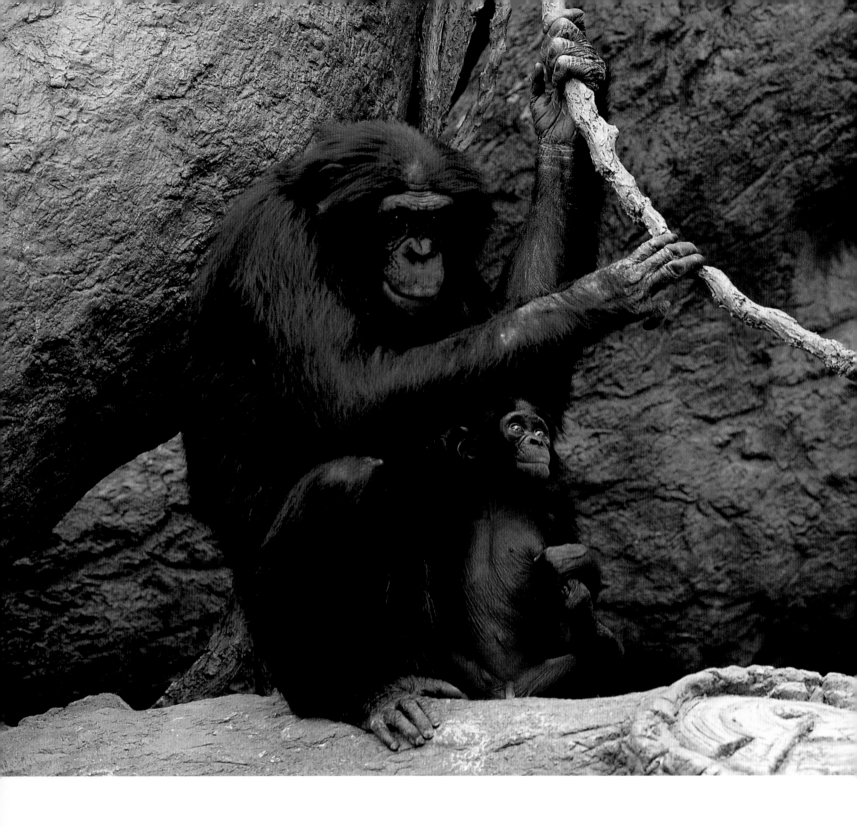

FACING PAGE

*A curious infant bonobo*
*inspects its surroundings*
*without losing its grip on*
*its mother. Observers have*
*noted that ape mothers*
*often play games with*
*their infants that promote*
*direct eye contact, further*
*cementing a bond that*
*may last a lifetime.*

ART WOLFE

## Clingy Bonobos

After a gestation period of 220–230 days, bonobos birth a single, 1–2 kilogram (2.2–4.4 pound), dark-faced infant. The newborn clings to its mother's belly for the first six months, and then takes to riding jockey-style on her back. A bonobo infant develops more slowly than its chimpanzee cousin. By one year of age, a chimpanzee is exploring the world and playing with others, but a young bonobo remains steadfastly attached to its mother, rarely even walking on its own. Not until it is a year and a half does the infant let go of its mother to play with others in the community.

Males often play with an infant, but it is the mother that does most of the work. She nurses her youngster for four years and carries it everywhere. A bonobo female can conceive again less than a year after giving birth, before her infant is even weaned, since she even copulates while pregnant. This means that sometimes a female gives birth to a second infant very quickly, and she may end up nursing two offspring simultaneously, carrying one on her chest and another on her back.

By age five or six, a young bonobo grows increasingly independent. A daughter especially starts to spend more and more time on her own and eventually drifts away from her mother completely. A son almost always remains close to his mother; their relationship builds his social standing within the community.

## FINDING FOOD

Most great apes live in the deceptively productive rain forests, where an equable year-round climate allows plants to grow abundantly with little seasonal change. With vegetation everywhere, it might be imagined that apes have little trouble finding adequate food. This is not always so. Vegetation tends to be a poor diet since it is often low in protein and much of it is hard to digest. Animals that rely on grazing or browsing must feed long hours to get enough energy. However, higher-quality plant material is available in the forest—in the form of fruit and nuts—as are other protein-rich foods such as insects and other animals.

### Frugivorous Orangutans

Orangutans are the fruit-eaters of the rain forest. At times, they eat nothing but fruit, especially such delicacies as soft, nutritious figs. When fruit is scarce, they eat crunchy bark and leaves and other plant parts from more than five hundred species. Less than 1 percent of their diet is animal matter—including insects, eggs, fledgling birds, and even small, wide-eyed primates called slow lorises (*Nycticebus coucang*) weighing about 2 kilograms (4.4 pounds).

To find the fruit that is scattered throughout the rain forest, orangutans develop detailed mental maps, almost like a photographic memory. They can remember where, and more importantly when, a particular tree will be fruiting. Forests are made up of countless trees of many different species, and each bears

FACING PAGE

*A male orangutan opens a durian fruit to feed on its custard-like pulp and chestnut-sized seeds. This 15–20 centimeter (6–8 inch) round fruit has a hard external husk that prevents many female orangutans from enjoying its contents. Male orangutans, being much stronger than females, are able to break the husk open without too much trouble.*

NEIL P. LUCAS/BBC NATURAL HISTORY UNIT

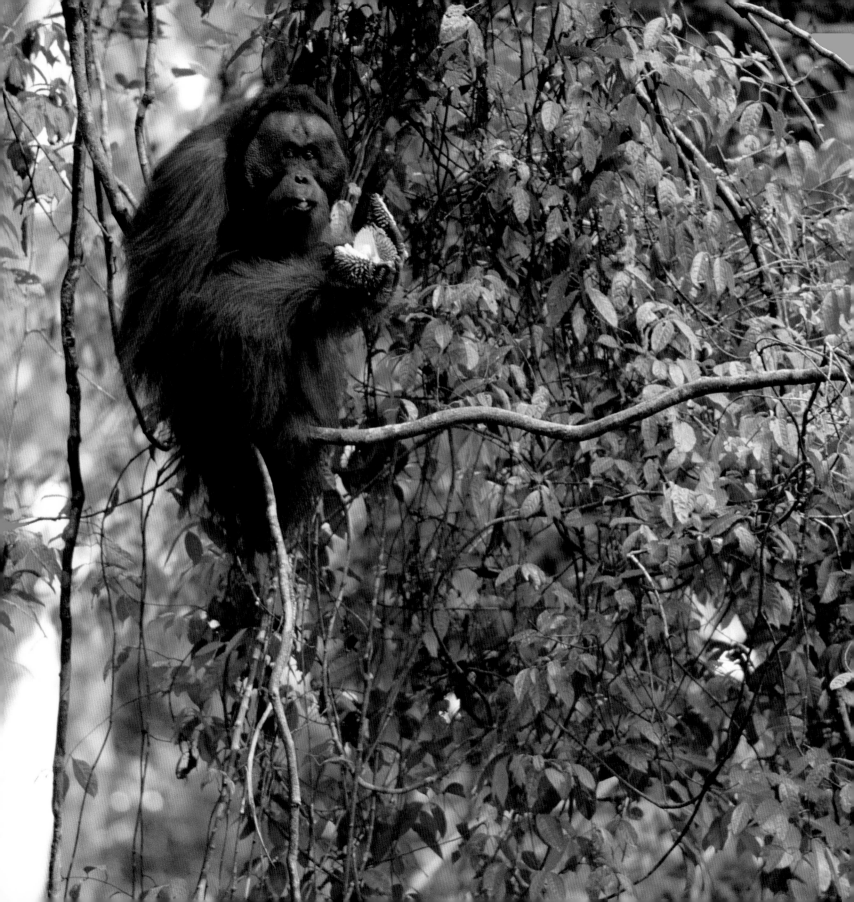

MALE ORANGUTANS DO NOT EAT MORE FOOD

BY VOLUME THAN FEMALES, BUT THEY FAVOR

HARD, HIGHLY NUTRITIOUS, FAT-RICH SEEDS

THAT FEMALES ARE NOT

STRONG ENOUGH TO

OPEN. WHEN FRUIT IS

SCARCE, ORANGUTANS

TAKE IN FAR FEWER

CALORIES AND OFTEN

LOSE WEIGHT AS THEY

METABOLIZE BODY FAT.

fruit at various times of the year. Only about one in a hundred trees bears fruit at any one time. Remarkably, orangutans know the schedules of many of the fruit trees within their territory.

Since fruit trees are widely dispersed in the forest, orangutans usually feed alone to reduce competition. Only when a tree is laden with fruit do orangutans feast together, and even then tensions can run high. When fruit is plentiful, male orangutans eat up to two and a half times their daily 3350-kilocalorie requirement, whereas females consume nearly five times their 1500-kilocalorie minimum. Male orangutans do not eat more food by volume than females, but they favor hard, highly nutritious, fat-rich seeds that females are not strong enough to open. When fruit is scarce, orangutans take in far fewer calories and often lose weight as they metabolize body fat. Females especially are likely to be more severely affected by fruit scarcity because of the physical demands of pregnancy and infant-rearing, factors that may explain the long interval between births.

Although orangutans are almost completely herbivorous, meat-eating has been observed. Between 1989 and 1999, there were just seven observations of adult female Sumatran orangutans with dependent offspring killing and eating slow lorises (and in one case a gibbon, *Hylobates* sp.). They do not appear to plan a hunt but simply act if they stumble upon potential prey, such as slow lorises, that are easy to catch and kill with a bite to the skull. Within two hours of the kill, females usually consume all of the prey's body parts, including the brain and the eyes. Sometimes they share the meat with their offspring. Only females have been seen eating meat, but it is not known if this is a female trait since so few hunts have been observed. The nutritional strain of nursing may provide females with an extra incentive for hunting.

## Browsing Gorillas

The two subspecies of lowland gorillas and the mountain gorilla have distinct diets based, in part, on their differing habitats. Fruit may make up more than a quarter of the diet of lowland gorillas, and they may travel more than 3 kilometers a day (nearly 2 miles) in search of the dispersed fruiting trees.

Mountain gorillas are the only apes with little or no fruit in their diet because it is scarce at high altitudes. Instead they feed on more than sixty types of herbaceous vegetation, including wild celery, nettles, and bamboo shoots. Since herbaceous vegetation is so prevalent in the montane rain forest, mountain gorillas have little need to defend territories or to cooperate with each other to monopolize a food source. The lack of competition for food may explain their fairly cohesive social structure. They also have little need to travel far in search of food, and daily movements are often less than a kilometer (0.6 mile).

An adult gorilla can eat 30 kilograms (66 pounds) in a single day—that's the equivalent of one-fifth an adult male gorilla's body weight or 40 percent of the average human male's body weight. When feeding, gorillas show incredible dexterity, carefully manipulating plants covered in stings, hooks, or spines. They even select certain sections of a plant and avoid others that contain high concentrations of toxic secondary compounds such as alkaloids that could result in stomach upsets or even death.

Gorillas trample plants and break branches whenever they eat. After mountain gorillas browse an area for a day or two, they avoid returning to it for several months. If they were to return to a food patch too soon after feeding in it, they could prevent recovery and cause a steady decline in plant productivity. Bamboo, in particular, needs six to eight months to recover from trampling and grazing pressure.

Although gorillas have never been seen eating meat in the wild, some populations are known to eat insects, sometimes breaking open ant or termite mounds

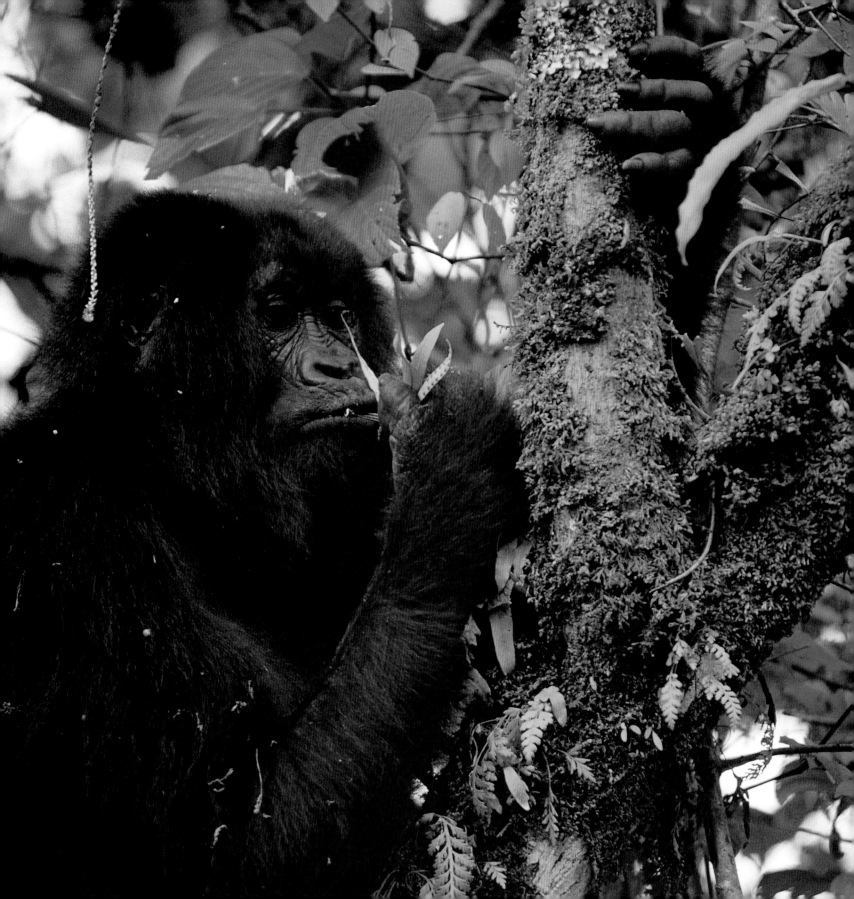

FACING PAGE

*Gorillas spend about half
of all daylight hours
feeding. Mountain gorillas
rarely need to climb to eat,
since the herbaceous layer
in the mountain forest
is so dense. With food
everywhere, they can
simply reach out and
grab whatever is nearby,
moving only when they
have exhausted the
desirable food items
within arm's reach.*

KENNANWARD.COM

with brute strength. Mountain gorillas usually only ingest insects incidentally, as they are eating vegetation, but lowland gorillas eat insects more regularly. In some areas, more than 40 percent of lowland gorilla feces contain insect remains.

Gorillas may also have culturally based food preferences. Gorillas at Ndoki Forest, Congo, eat the fruit of *Polyalthia suaveolens*, whereas gorillas at Lopé, Gabon, do not. Gorillas from Belinga, Gabon, consume termites but not weaver ants; the opposite is true at Lopé. These examples suggest that gorillas do not simply eat a food because it is available but because they like it.

## Omnivorous Chimpanzees

Chimpanzees have diverse diets. Although they eat primarily fruit and herbaceous vegetation, they also eat meat and insects. The size of chimpanzee groupings is directly related to how much food is available and where it is located. When food is scarce, chimpanzees spend more time foraging alone or in small groups; only when it is abundant do they form larger groups, and even then they keep their distance.

The proportions of each food source in the chimpanzees' diet is closely related to habitat type. Chimpanzees in the rain forest eat large amounts of herbaceous vegetation. Such plants may form more than a third of their diet, especially when fruit is scarce; when fruit is abundant, it forms most of the animals' diet. Meat and other animal matter is consumed at only small levels, making up less than 5 percent of the total diet.

The situation is different for woodland-savanna chimpanzees. In these drier habitats, herbaceous vegetation is used to a far lesser degree, probably because it has less nutritional value and is less abundant than similar vegetation in the rain forest. These chimpanzees exploit fruit, just as their rain forest relatives do, but the difference is made up with meat and insects, not other vegetation.

Just as gorillas have preferences for certain foods, so do chimpanzees. More than 286 food items are common to the two Tanzanian study sites, Gombe and Mahale, but only 104 of these are eaten by both chimpanzee populations. Chimpanzees at Gombe eat oil palms, whereas those at Mahale do not. In Mt. Assirik, Senegal, the chimpanzees hunt nocturnal primates such as small, wide-eyed galagos (*Galago senegalensis*) and pottos (*Perodicticus potto*), but they do not hunt the forest monkeys or small forest antelopes called duikers (*Cephalphorus* sp.) as their eastern relatives do.

Chimpanzees are proficient hunters. Before 1960, they were believed to be completely herbivorous, except for eating insects such as ants and termites. Long-term studies soon revealed that hunting is part of the chimpanzee way of life. Chimpanzees kill at least thirty-two species of animals, including eighteen different primates (mainly forest monkeys), but they seem to prefer red colobus monkeys (*Colobus badius*). At Mahale, Gombe, and Taï, Côte d'Ivoire, red colobus make up between 50 and 80 percent of all kills. At Gombe, more than 90 percent of hunts are conducted by males. Males often share their catch with sexually receptive females, possibly to gain a mating advantage.

Hunting strategies differ dramatically between populations. Among the scattered woodlands of Gombe, males often hunt alone, cornering female red colobus and their offspring in an isolated tree. Any cooperation between hunters is generally opportunistic. Once the monkey is trapped, the male chimpanzee snatches the infant but rarely attacks the mother. In the rain forests of Taï, where a more continuous forest gives the colobus numerous avenues of escape, two to six adult male chimpanzees cooperate to capture their prey. When they pursue red colobus, they seize both the adult and the infant.

Despite the apparent penchant chimpanzees have for meat, they rarely scavenge carcasses of animals killed by other predators. Although animals killed by

FACING PAGE

*Chimpanzees feed for six to eight hours each day, ranging as far as 15 kilometers (9 miles) in search of food. They have two feeding peaks, usually early in the morning and in the mid-to-late afternoon. When they come across fruiting trees, chimpanzees spread out, giving each other plenty of space and reducing competition and aggression.*

ART WOLFE

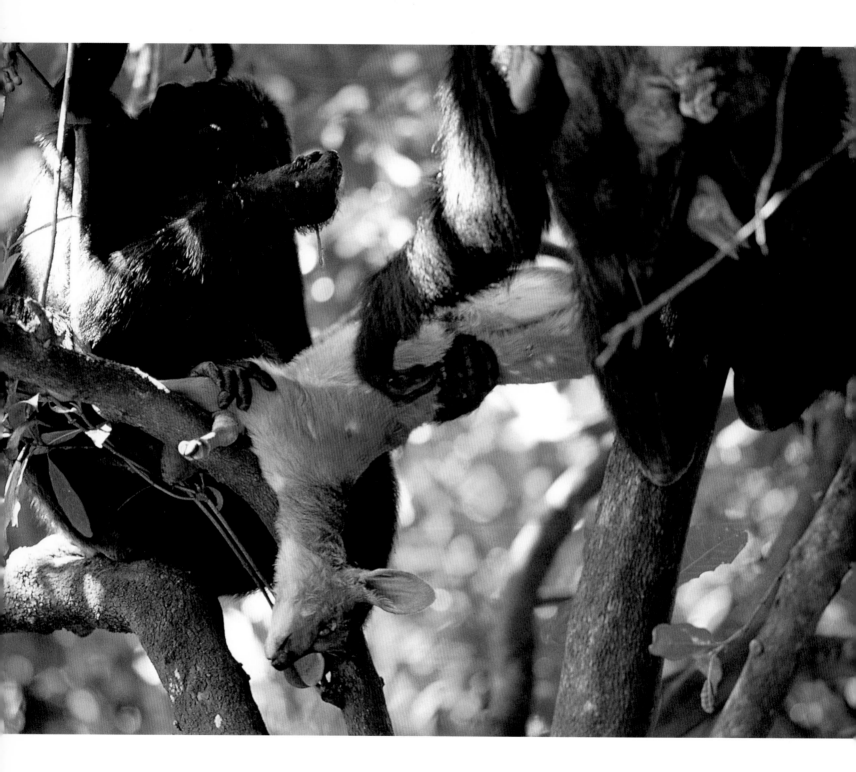

CHIMPANZEES ARE PROFICIENT HUNTERS.

BEFORE 1960 THEY WERE BELIEVED TO BE

COMPLETELY HERBIVOROUS, EXCEPT FOR

EATING INSECTS SUCH AS

ANTS AND TERMITES.

LONG-TERM STUDIES SOON

REVEALED THAT HUNTING

IS PART OF THE CHIM-

PANZEE WAY OF LIFE.

chimpanzees are torn apart and eaten within minutes, animals that are found dead are the source of considerable consternation and even fear. Thus, hunting by chimpanzees may be of more importance for its social value than simply for the nutritional value of the meat.

## Harvesting Bonobos

Bonobos feed on the rain forest's abundant herbaceous vegetation and its regularly available fruit. The verdant rain forests of Congo/Zaire are seasonally stable and productive year-round. However, rain forests are not homogenous habitats but consist of a mosaic of forest types, including primary and secondary forest, swamp forest, and dry forest. Bonobos use the primary forest every day, especially when their favored fruit is out, whereas secondary and swamp forests are used between fruiting seasons.

Herbaceous vegetation—including protein-rich species such as ginger and arrowroot—may form more than a third of their diet, especially when fruit is scarce; when fruit is abundant it may make up 80 percent of food intake. Although more than 114 plant species are eaten, bonobos consume little meat, and animal matter usually makes up less than 1 percent of their total diet. However, they are known to eat earthworms, butterfly and moth larvae, beetles, millipedes, snails, and honey. Mammalian prey such as flying squirrels (*Anomalurus* sp.), bats (*Eidolon* sp.), shrews, and infant duikers (*Cephalphorus dorsalis* and *C. nigrifrons*) are taken more rarely.

Even if bonobos stumble across potential mammalian prey, they rarely attempt to catch it. Bonobos have been observed occasionally catching and restraining monkeys such as black-and-white colobus (*Colobus angolensis*) and black-cheeked white-nosed monkeys (*Cercopithecus ascanius*), sometimes with fatal results, but they have never been seen hunting, killing, or eating them.

## MASTERS OF INVENTION

Tool use is one of the most intriguing of ape behaviors, for it is here that we catch a glimpse of our own ancestors at work. Tools supplement physical ability, and the use of tools requires that the animal *think* about what it is doing and what it wishes to achieve. Although others among the great apes are known to make tools, it is the chimpanzee that excels at invention.

Some chimpanzee populations have never been seen using tools, but at least thirty-six populations use tools regularly. Tools are used mainly to access hard-to-get-at foods, such as ants or termites or embedded foods like nuts. Perhaps the chimpanzees in non-tool-using populations do not *think* about the problems they face in the same way, or perhaps alternative foods are freely available. After all, necessity is the mother of invention: if there is no necessity, there is no need for invention.

Chimpanzees' tools have a variety of purposes. Chimpanzees break grass stems or twigs to fish for ants or termites, dip for honey, probe for bees, or pick marrow from a bone. They soak up drinking water, and wipe feces or dirt from their bodies with leaves and moss. They brandish, throw, and haul large sticks and branches along the ground to display at other chimpanzees. They throw sticks and stones to defend themselves from leopards or snakes, and they tickle other chimpanzees with a stick to invite them to play.

Sometimes chimpanzees use different methods to reach the same goal.

FACING PAGE

*Concentration fills the face of this female eastern chimpanzee in Tanzania's Mahale Mountains National Park. With great care, the chimpanzee inserts a grass stem into a hole in the tree. Ants will bite on the intruding stem, and the chimpanzee will then carefully withdraw her tool and eat her catch.*

GUNTER ZIESLER/
PETER ARNOLD, INC.

TOOL USE DIFFERS MOST SIGNIFICANTLY

BETWEEN THE NUT CRACKERS OF FAR WESTERN

AFRICA, AND THE NON-NUT CRACKERS OF THE

REST OF AFRICA. AT LEAST

THIRTEEN WEST AFRICAN

CHIMPANZEE POPULATIONS

CRACK NUTS USING STONE

HAMMERS AND STONE OR

WOODEN ANVILS.

Chimpanzees at Mt. Assirik, Senegal, and at Gombe and Mahale, Tanzania, break twigs or grass stems to a specific length and chew them at one end to make them brush-like before using them to fish for termites. In central West Africa, chimpanzees dig out termites, but they do not fish for them. At Kibale, Uganda, and Taï, Côte d'Ivoire, chimpanzees use their hands on the rare occasions that they eat termites.

At Tongo, Congo/Zaire, chimpanzees collect drinking water with sponges made of moss, at Gombe they use leaf sponges, and at Kibale they rely on stem sponges. Other apes simply lick rainwater from their fur or drink from puddles. A few tools are unique to one or two populations. Leaf cushions keep chimpanzees in Bossou, Guinea, from sitting on wet ground, whereas chimpanzees in Tenkere, Sierra Leone, hold sticks with their feet and sit on other sticks to protect them from kapok tree (*Ceiba pentandra*) thorns while feeding on its fruit.

Most tasks need just one tool, but a few jobs call for more. In Congo's Ndoki Forest, chimpanzees puncture termite mounds with small, stout branches 50 centimeters (20 inches) long and 10 millimeters (0.4 inch) around. Then they push probes made from flexible plant stems 50 centimeters (20 inches) long and 5 millimeters (0.2 inch) wide into the holes to fish out the termites. One chimpanzee, released from captivity onto a semi-wild island in the Gambia River, broke into a bees' nest with a dead branch she used as a chisel. The eleven-year-old female then widened the hole with a sharper, pointed "chisel," perforated the nest's seal with a green branch 10 millimeters (0.4 inch) wide, and finally extracted honey from the nest with a fourth tool, a 75–80-centimeter (30–32-inch) long fishing probe. Chimpanzees are without a doubt determined animals.

Tool use differs most significantly between the nut crackers of far western Africa and the non–nut crackers of the rest of Africa. At least thirteen West African chimpanzee populations crack nuts using stone hammers and stone or wooden anvils. Chimpanzees to the west of the Mzo-Sassandra River, including

those in Taï National Park, place especially hard nuts from a variety of species onto a stone or wooden anvil, such as an exposed rock or a tree-root depression, and pound open the nuts with a hammer stone that weighs up to 20 kilograms (44 pounds). They carefully select small hammers and larger anvils but rarely attempt to modify them, probably because they are too hard.

Learning how to crack nuts can take some time. At Taï, mothers leave the tools and nuts around or carefully position the nut on a wooden anvil, and may even show the youngster how to hold the hammer. It can take four years of practice to become adept. However, some chimpanzees never seem to learn the proper technique. At Bossou, one eight-year-old female consistently acted like a three year old. She tried to crack nuts with her hands or feet, but never with a hammer. This female was incapacitated by a wire trap at age four, and her learning was disrupted at a critical stage. She never learned how to manipulate the hammer stone and was unable to catch up as she grew older.

If chimpanzees learn how to crack nuts by watching others and possibly receiving instruction from their mothers, that may explain why other populations, even though they have access to both nuts and the appropriate tools, never develop the skill—they just do not know what to do. At Gombe, chimpanzees open hard fruit by pounding them against the ground, but these animals have never been seen using another object to open fruit or nuts. Nut cracking probably arose in the western chimpanzee after the subspecies was geographically isolated from other populations during the Pleistocene, 17,000 years ago.

Bonobos and orangutans both use tools to a far lesser degree than chimpanzees. Bonobos rarely use tools to get food, and they never use objects as weapons. Instead, they make rain hats, fly-swatters, napkins, and sponges from leaves; scratch their backs, dig in the ground, and pick their teeth with sticks; and play with branches. However, none of these activities is seen regularly. Males do

have a tendency to drag branches to show dominance or to guide their group in a particular direction but, used this way, the objects may not really be tools.

Once thought to be non-tool users, Sumatran orangutans are now known to modify sticks regularly to probe for insects or to pry seeds from fruit. Orangutans also use leaves to shield themselves from the rain, and they wrap thick foliage around their hands and feet to protect them from thorns while feeding. Rehabilitated orangutans that have spent time around humans often use tools more than their truly wild counterparts. They make leaf vessels to hold food and even use stick utensils to bring food to their mouths, suggesting that they are imitating people. Whereas captive gorillas frequently use tools to reach food, wild populations have never been seen using implements. However, it may be that observers have simply missed their use amid the dense vegetation of the rain forest. In time, researchers may add the gorilla to the short list of non-human tool users.

All three subspecies of

chimpanzees, both

lowland gorillas, and

bonobos deliberately

swallow the leaves of

certain plants. Early in

the morning, often

before they eat, the

apes carefully fold

the foliage in their

mouths using their

tongues.

## APES PRACTICING MEDICINE

One of the most interesting discoveries of recent years is that all three of the African apes self-medicate in the wild by eating minerals or clays, by ingesting whole leaves, or by chewing the bitter pith of certain plants.

When they have stomach upsets, especially diarrhea, great apes often eat earth in a practice known as geophagy. At Mahale, Tanzania, chimpanzees consume earth from termite mounds. The soil is high in metahalloysite, a partially hydrated clay that treats diarrhea by reabsorbing water from the large intestine. People around the world have used similar methods for centuries.

For the mountain gorillas of Virunga, geophagy may help them adjust to dramatic dietary changes. During the dry season, mountain gorillas feed on many toxin-bearing plants, including cyanide-rich bamboo, that can cause acute diarrhea and dehydration. Like chimpanzees, gorillas eat clay that minimizes these symptoms. In at least three locations, gorillas have mined huge caverns to get at the soils they crave.

All three subspecies of chimpanzees, both lowland gorillas, and bonobos deliberately swallow the leaves of certain plants. Early in the morning, often before they eat, the apes carefully fold the foliage in their mouths using their tongues. They take in anywhere from one to one hundred stiff-haired, bristly leaves intact, without chewing. Because the rough greenery is the first thing to travel through the stomach, often in just six hours or a quarter of the normal processing time, it

irritates the lining, forcing anything that is in the stomach out with it. The leaves are later found, undigested, in the animals' feces.

There is a significant relationship between the presence of whole leaves and the nematode *Oesophagostomum stephanostomum* in the feces of chimpanzees. This suggests that chimpanzees ingest the leaves when they are infected with the parasites. The more than 30 species of leaves that apes swallow do not seem to share any significant biologically active chemicals, and the expelled nematodes are always found alive. The irritation caused by the rough leaves passing rapidly through the gastrointestinal tract seems to be enough to flush the worms out.

In addition to folded leaves, chimpanzees carefully peel back the bark and leaves on the young shoots of the shrubby *Vernonia amygdalina* plant to ingest its bitter pith. The pith appears to dramatically lower the number of nematode eggs being produced, and sick chimpanzees recover, like humans, about twenty-four hours after ingestion. Nematode infections can be very serious and, left untreated, repeated infections cause abdominal pain, diarrhea, fatigue, and even death.

African apes use numerous potentially medicinal plants to treat illness, selectively eating such parts as the bark, pith, leaves, or berries. Since many of these plants are bitter, the apes must first learn to overcome their aversions just as humans learn to take foul-tasting medicine. It may be that apes actively select bitter plants or plant parts because they are more likely to contain toxic compounds with secondary, medicinal properties. It is also likely that the use of plants to treat illness is a behavioral tradition passed from mother to offspring through imitation or teaching, and thus from generation to generation. Interestingly, evidence is now being gathered to suggest that there are regional traditions in the species selected for swallowing. Clearly, transmission of knowledge about what species are useful for parasite control has been passed down through the generations over large areas of African ape habitat.

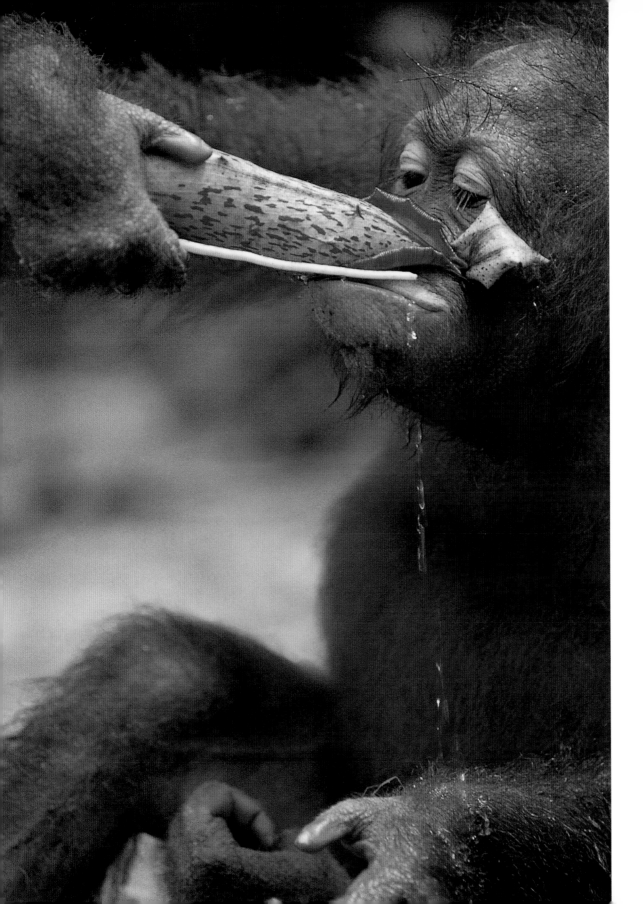

Communication is at the root of all relationships. It enables animals to convey information to others and to influence their actions. Communication can be verbal through a variety of calls or non-verbal through body language. In dense forests, the only way to communicate with others may be vocally. Visual signals only come into play when animals can see each other.

In the forests of Southeast Asia, male orangutans roar their lion-like long call that can be heard for up to a kilometer (0.6 mile). Subadult males steer clear, as do females with dependent offspring, but rivals may approach a caller to challenge him for his territory. Receptive females may seek him out to mate. Although the males' long call is the best known, orangutans make thirteen distinct sounds; many are soft, gentle calls between mothers and young.

Gorillas have a large repertoire of calls. They roar, hoot, scream, and bark, and make a sound of contentment that is a cross between a dog whining and a human singing. Adult males call mostly to prevent disputes between females or during conflicts with other males. Silverbacks roar explosively when threatened. They also have a short bark to demand that an unseen animal identify itself. Females make mostly "close calls," including numerous belching sounds of contentment and mildly aggressive grunts made when disputing access to food. Juveniles and infants cry during temper tantrums, but they rarely scream unless they are left alone. Youngsters often chuckle happily while they play.

FACING PAGE

*Chimpanzees produce a wide variety of sounds. Their calls express such emotions as fear, anger, rage, uncertainty, annoyance, distress, enjoyment, and excitement. Chimpanzees also have a distinctive hunting bark and a capture call to alert others to a successful pursuit.* ANUP AND MANOJ SHAH

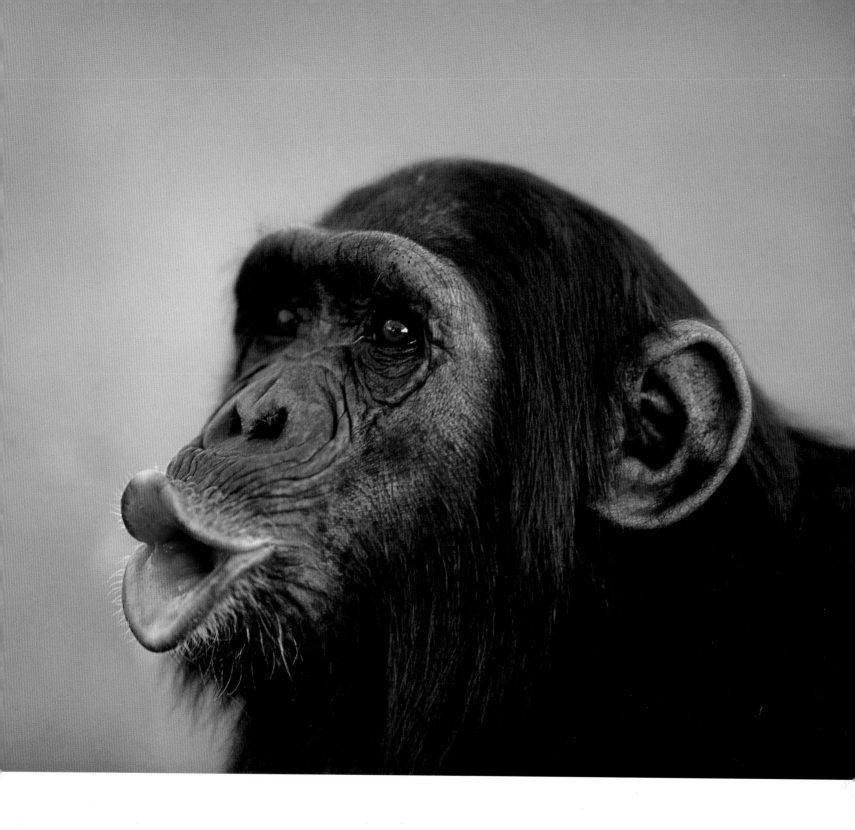

Chimpanzees have four basic calls, each with several variations. They grunt, bark, scream, and hoot in more than thirty-two distinct ways from "wraas" and "huus" to squeaks and pants. Calls identify individuals, and chimpanzees often rescue relatives threatened by another animal but ignore non-relatives. Other calls are spontaneous emotional responses; chimpanzees make specific calls when they are afraid, puzzled, excited, angry, or feeling sociable. Chimpanzee calls can also convey information such as how much food is available at a particular location, where to find a food cache, or if a predator is nearby and even whether that predator is on the ground or in the trees.

The most distinctive of chimpanzee calls is the pant-hoot. Chimpanzees pant-hoot during periods of intense social excitement. The call consists of a long, low-frequency introductory sound that builds up to a series of short, rapid calls; a loud climax; and then ends with some more short, quick calls. It is the typical "Cheeta" call heard in *Tarzan* movies. To attract allies and/or mates, adult males often pant-hoot when they arrive at fruiting trees. The sound may convey the caller's social status to all that can hear him.

Compared with chimpanzees, bonobos are talkative and shrill. They chatter almost constantly in high-pitched peeps and barks that can only be heard at close range, almost as if they are talking to themselves. Male bonobos whoop like small yapping dogs across long distances to let others know where they are. Males also alternate their calls to avoid drowning each other out, a unique bonobo practice known as vocal matching.

Vocalizations often accompany changes in body language or displays. Adult male orangutans may break branches and noisily throw them to the ground to intimidate their opponents. Gorillas crash into vegetation, tear into shrubs, or beat their chests before lunging or bluff charging at their rivals. Male chimpanzees call aggressively as they drag branches, throw sticks and stones, or even jump

over other animals when they charge at them. Their hair often stands on end during disputes, so they look larger and more impressive as they strut in front of a rival. Male bonobos also drag branches but their hair rarely stands on end, and their displays are far more subdued.

Apes' faces are incredibly expressive. They grin to submit to higher-ranking animals or when they are nervous, they pout when anxious or frustrated, they smack their lips while grooming, and they bare their teeth in fright or anger. When they want to play, they make a "play face" by opening their mouths without showing their teeth.

No one knows if non-human apes think in the way that people do. At times they seem to deceive each other, suggesting that they can predict how another individual will react to their actions. To keep food to themselves, chimpanzees intentionally avoid a food cache until they can get at it without being seen. To avoid reprisals from alpha males, male chimpanzees cover obvious erections with their hands. And to hide fearful expressions that others may take as a sign of weakness, chimpanzees cup their hands over their faces. Both chimpanzees and gorillas have been seen to mate secretly, often hidden in vegetation, with both partners inhibiting their normal copulation calls to avoid drawing the attention of others to their actions. Deception or fear? No one knows exactly what motivates great apes to act in these ways.

Language is often defined as a peculiarly human achievement; in fact definitions of language are sometimes designed to specifically exclude non-human examples. However, apes can communicate subtle intentions and moods to others, and they can also learn elements of complex human or representational languages that use signs or symbols to denote words. A number of apes, including Washoe, Moja and Ai (chimpanzees), Koko and Michael (lowland gorillas), and Kanzi (bonobo), have participated in such language experiments.

Washoe was born in the wild in 1965. She was acquired as a ten-month-old infant by what would become the Chimpanzee and Human Communication Institute (CHCI) at Central Washington University, and taught American Sign Language. By age four, she knew 132 words, and by age thirty-four she reliably used 240 signs. She signs to herself when looking at pictures in a book and signs "hurry" when rushing off to use the toilet. Washoe even taught her adopted son Loulis 55 signs. Another chimpanzee at CHCI, Moja, reportedly jokes with her trainers and seems to understand the rudiments of metaphor; for example, after putting a purse on her foot, she walked around with it signing: "That's a shoe."

Koko and Michael, from Francine Patterson's Gorilla Language Project, know nine hundred and six hundred American Sign Language words, respectively, although their working vocabulary is somewhat lower. In addition, Koko seems to understand more than two thousand spoken English words and scored between 70 and 95 on an IQ test. The average human score on such tests is 100.

Both Kanzi, the bonobo at Georgia State University's Language Research Center, and Ai, a chimpanzee being studied at Kyoto University, have mastered grammar and sentence structure. They know when a word is a subject or an object. When asked to "give the dog a shot," Kanzi takes a toy syringe and injects a stuffed toy dog with it. The remarkable achievements of these and other animals in language programs may yet shed light on how language and thought evolved in our own species.

FACING PAGE

*Western lowland gorillas, like this male, are practiced at conveying emotion and intent through body language and facial expressions. The gaze of a relaxed gorilla is often described as bland, where-as an annoyed gorilla tends to purse its lips, scowl, and stare directly at the object of its annoyance.*
ART WOLFE

# OF APES

*Chapter Three*

# AND HUMANS

## FROM MYTHS TO MOVIES

Orangutans, gorillas, chimpanzees, and bonobos lend themselves well to fanciful storytelling. They look enough like people to be easily attributed human emotions and desires. The traditional tales of great apes told by indigenous peoples in Southeast Asia and Africa have mostly been lost or forgotten. But a few stories, passed orally from generation to generation, do exist. In some tales, apes are the symbols of gods; in others, the bestial shadows of people. The stories are highly anthropomorphic, and as such they tell us more about people than apes.

In Africa, many myths place the ape—usually a chimpanzee—in an intermediary role between animal and human. In Cameroon, a story tells of thirteen monkeys that carry off the baby daughter of a man who lives in the forest. To win their trust, the man drinks a special medicine that turns him into a monkey. After living with the animals for a year, the man successfully learns their language and discovers that they want to marry him. He weds each of them and, in time, thirteen babies are born. One day when the monkeys are sleeping, the man snatches up his human daughter, runs back to his home, and reverts to his human form. Several times over the coming years he visits the monkeys, and each time they give birth to more of his children. Eventually a new race is born: the chimpanzee.

Among several African cultures, including the Bulu of Cameroon and the Pygmies of the Congo, apes are associated with the acquisition of fire by humans.

FACING PAGE

*Despite our increasing understanding of, and compassion for, apes, there are still places where they are little more than sideshow attractions. This orangutan performs in a Las Vegas act dressed as a rock star. Such images reinforce the public's view that apes are little more than imitation humans, caricatures without vibrant and rich personalities of their own.* MICHAEL NICHOLS/NGS IMAGE COLLECTION

In Cameroon, it is said that Zambe, son of the god Mebe'e, created a chimpanzee, a gorilla, an elephant, and two men—a European and an African. Zambe gave each of them the tools of survival—fire, water, food, weapons, and a book. Sometime later, Zambe returned to see how they were faring. The chimpanzee and gorilla had discarded all but the food, and Zambe banished them to the forest. The elephant could not remember what he had done with any of the tools, and he too was exiled. The European held on to the book but cast off the flame, whereas the African discarded the book but kept the flame. Thus, say the Bulu, Europeans are the keepers of books, but Africans are the guardians of fire.

In Pygmy mythology, it was the chimpanzee that first possessed fire and humans that stole the gift. The story goes that a Pygmy man found the chimpanzees' village and sat by their fire to warm himself. As he moved closer to the flames, the chimpanzees warned him that his bark-cloth robes would catch fire. The man ignored their warnings and sat even closer. When his clothes ignited, he jumped up and ran back to his people, taking the fire with him. The chimpanzees gave chase, but by the time they reached the man's home, he had set blazes everywhere. The chimpanzees later abandoned their own village and returned to the forest to live without fire and eat only wild fruit.

To Indonesian indigenous tribes such as the Dayaks of Borneo, the lone Asian ape, the orangutan, is revered. They eat orangutan parts during sacred ceremonies and use orangutan skulls to invoke the name of the spirit god Antu Gergasi in religious rituals. Elsewhere, though, storytellers have spun salacious tales about male orangutans that kidnapped and ravished women, while in Africa gorillas have faced similar slander. These stories probably began when people observed male great apes aggressively pursuing their females, and over time, authors exaggerated and embellished the original tales.

The Carthaginian navigator Hanno made the earliest known sighting of an

African ape by a non-African in 470 BCE (Before Current Era). Hanno returned home from Africa's southwest coast with the pelts of three "wild women." He claimed that he and his crew were attacked and that they killed the creatures in self-defense. Although the species Hanno encountered is not known, the animals were probably chimpanzees or gorillas.

Scattered references in the seventeenth century illustrate a growing interest in and exposure to, if not an understanding of, great apes. William Shakespeare probably based his character Caliban from *The Tempest* ("a freckled whelp, hag-born . . . not honour'd with human shape") on early reports of chimpanzees. In 1625, the English explorer Andrew Battell described a giant "pongo" (gorilla) he saw while a captive of the Portuguese in West Africa. In 1641, the first detailed anatomical description of a chimpanzee was published, to be followed in 1658 by a similar account of the orangutan. Sixteenth- and seventeenth-century Portuguese reports indicate that people even saw chimpanzees using tools 450 years before scientists made that discovery. Father Barreira, a Jesuit priest, reportedly said that "all the animal lacks is speech."

*Many African cultures tell stories of apes and humans. This wooden statue from Congo/Zaire reflects those tales.* MUSÉE DE L'HOMME/ PHOTO M. DELAPLANCHE

Although Charles Darwin did not mention apes or humans specifically in his 1859 work, *On the Origin of Species*, the book triggered vigorous debate on evolution and true human origins. Later, in his 1871 book, *The Descent of Man*, Darwin detailed the evidence for human evolution from "lower forms" and noted that "the correspondence in general structure, in the minute structure of the tissues, in chemical composition and in constitution, between man and the higher

EXPLORERS STILL

INVARIABLY DESCRIBED

APES AS "EXCEEDINGLY

FEROCIOUS" OR AS

"HALF-MAN, HALF-BEAST,"

BUT TIMES WERE

GRADUALLY CHANGING

AS MORE PEOPLE HAD

CONTACT WITH APES.

animals, especially the anthropomorphous apes, is extremely close." Darwin went on to speculate, at a time when such speculation was unheard of, that Africa was the likely site of human evolution. Explorers still invariably described apes as "exceedingly ferocious" or as "half-man, half-beast," but times were gradually changing as more people had contact with apes. Fantasy was gradually being replaced by fact except in the entertainment industry, where audiences still demanded more dramatic interpretations.

Great apes burst onto the big screen with 1933's *King Kong*, which paved the way for screen adaptations of Edgar Rice Burroughs's *Tarzan* and Rudyard Kipling's *Jungle Book*. These tales represented apes as savage, giant monsters or as gentle, surrogate human parents. Simply put, the apes in films behaved more like humans than apes. Today's films are not much more realistic. *Planet of the Apes* and its sequels introduced talking apes that lorded over mute humans; *Every Which Way But Loose* and *Any Which Way You Can* paired Clint Eastwood with a smoking, beer-drinking orangutan; *Buddy* featured an eccentric's pet gorilla dressed in a tuxedo; and the recent remake of *Mighty Joe Young* kept the original's oversized gorilla.

Few movies have accurately portrayed great apes' lives, although *Gorillas in the Mist*, the film version of Dian Fossey's book, probably comes closest. For most people, television documentaries are the best chance to view apes as they really are—sometimes aggressive, occasionally brutal, but more often caring and gentle animals living in complex societies.

Humans are the most successful great apes. We are no longer shaped by our environment; we determine it. We are the only ape with a near-global distribution and numbers in the billions—passing six billion in October 1999. Our sheer numbers threaten to overwhelm countless species, including our closest relatives.

## Populations In Peril

Most great ape population estimates are well-educated guesses. Dense vegetation makes travel difficult and animals hard to see, so most surveyors count nests rather than actual animals. Censuses assume that each nest holds one animal, meaning that unweaned youngsters that share their mother's nest are not counted. Political unrest can also make it dangerous, and in some cases impossible, to survey ape habitats. As a result, researchers are often forced to extrapolate from scant data.

The orangutan population is currently estimated at less than 25,000 animals. Between 1976 and 1978, as many as 15,000 orangutans lived in Sumatra, but more recent surveys estimate just 9200 animals. Approximately 90,000 orangutans existed in Borneo in the mid-1970s, but by the mid-1980s there were only 37,000, and in the late 1990s estimates were further reduced to less than 15,500.

Western lowland gorillas may number as many as 100,000 animals. This figure is much larger than previous counts, which estimated 40,000 animals, and is due to increased survey coverage of swamp forests that had been thought to be largely

devoid of gorillas. The Republic of the Congo and Gabon are now each thought to shelter 40,000 or more western lowland gorillas. An estimated 5000–15,000 eastern lowland gorillas existed in 1963. Some recent surveys suggest the population has remained stable, whereas others point to considerably fewer than 5000 surviving animals.

The future of the remaining mountain gorillas is more uncertain. In 1981, 254 mountain gorillas made their home in the Virunga Mountains. By 1989, this figure had grown to 324, and it then remained stable through the early 1990s. Another 320 gorillas live in Uganda's nearby Bwindi Impenetrable Forest National Park, but it is now unclear whether they are mountain gorillas, eastern lowland gorillas, or even a previously undescribed subspecies. Even with the Bwindi animals, the total population of this subspecies at the close of the twentieth century is less than 650.

In the late nineteenth century, as many as several million chimpanzees lived in Africa. One hundred years later, their population is believed to be a little over 100,000, although unsurveyed areas in northern and eastern Congo/Zaire may hold more animals. There are roughly 12,000 western chimpanzees, most of them in Côte d'Ivoire; 80,000 central chimpanzees, mainly in Gabon and Congo/Zaire; and 13,000 eastern chimpanzees roaming east of the Congo River.

Bonobos are undoubtedly one of the rarest great apes, but no one knows exactly how many existed in the past. Areas where many bonobos once ranged are now empty; their population may have been halved in the last two decades. Few locations in Congo/Zaire have large numbers of bonobos; less than 10,000, or, by some estimates, fewer than 5000 animals remain.

## Habitat Destruction

Apes cannot survive if they have nowhere to live. Between 1980 and 1995, 2 million square kilometers (800,000 square miles) of forest—an area slightly larger

IN SOME REGIONS, GREAT APES ARE HUNTED

FOR PURPORTED MEDICINAL USES. ALTHOUGH

EATING PRIMATES IS TABOO IN SOME CULTURES,

IN OTHERS CONSUMING

GORILLA FLESH IS

THOUGHT TO MAKE

PEOPLE STRONGER, AND

EATING BONOBO MEAT OR

OTHER PARTS IS BELIEVED

TO ENHANCE SEXUALITY.

than Indonesia or Mexico—was lost in developing countries. In Africa, 77 percent of the frontier forest—forest that has not been significantly altered or fragmented—is at moderate-to-high risk, mainly from logging. In Asia, the figure is approximately 60 percent.

Farming, development, and logging clear the forest, isolating animals in ever smaller areas. As apes become separated from their neighbors, they have fewer mates, reducing genetic diversity, and their fragmented habitat makes food hard to find. Starving animals raid farms to find food, leading to conflicts with farmers that the apes cannot win. Logging brings people into previously unsettled areas, and few apes can survive when their homes are regularly disturbed.

Less than 2 percent of the orangutans' former range is protected, and preserved areas are increasingly being encroached upon. Sumatra is losing its rain forests faster than any other Indonesian island. Logging and mining in Kalimantan—Indonesian Borneo—are decimating the forest, while the rain forest in Malaysian Borneo's Sabah region declined from 86 percent to 41 percent between 1953 and 1990. Across Indonesia, orangutans have lost 80 percent of their forest in twenty years, even before taking into account the recent devastating fires.

In 1997 and 1998, fires in Indonesia, set by plantation workers but made worse by drought, burned more than 30 000 square kilometers (12,000 square miles) of forest, including a significant amount of orangutan habitat resulting in the deaths of thousands of orangutans. Primary, undisturbed tropical rain forest is not like a plantation forest; once it has been razed, it cannot regrow.

In Africa, gorillas, chimpanzees, and bonobos survive mostly in the remote primary forests of central Africa. Even so, in Gabon and Congo, where substantial rain forests still exist, unprotected forests could be completely cleared in 125 years, while forests in Congo/Zaire, Equatorial Guinea, and Cameroon could be

FACING PAGE
*Although ape parts have been used in traditional folk medicines for centuries, wild populations can no longer sustain the growing demand. At one time, this trade was local or regional; today, it is international.*
HEATHER ANGEL

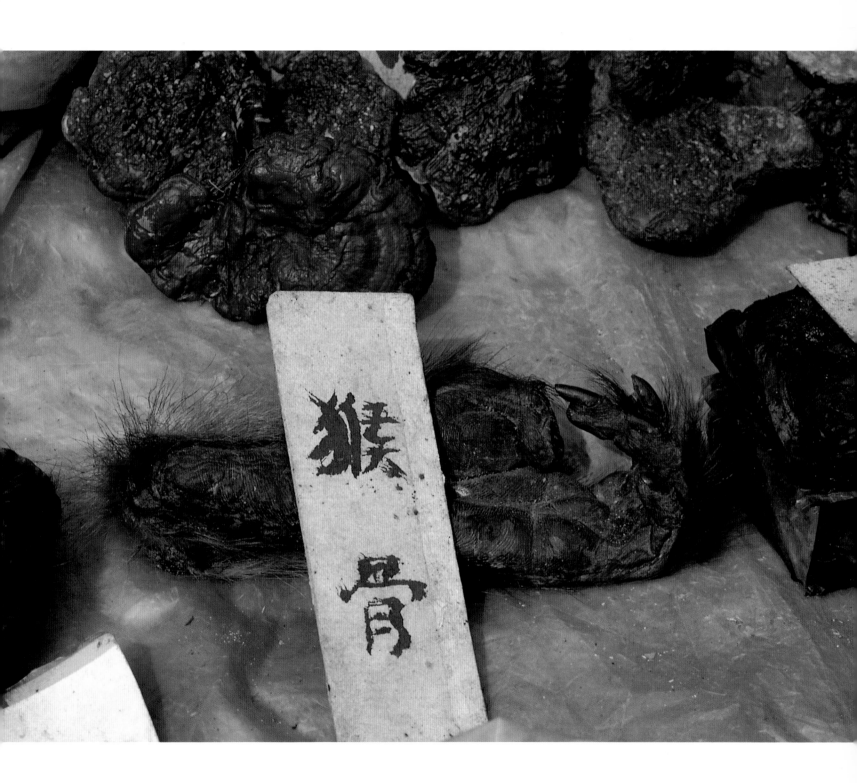

felled in the next 50–70 years. In far West Africa, most of the forest has already been destroyed.

## Illegal Hunting and Poaching

Indigenous peoples have always eaten wildlife meat known as bushmeat. When there were fewer people, their range limited, and their techniques simple, such harvests were sustainable. Today, however, more people are encroaching on previously untouched habitats, and their hunting techniques—firearms and wire snares—are far more effective.

In Central and West Africa, hunters kill at least 2000 gorillas and 4000 chimpanzees annually. More apes are killed accidentally in snares, or lose digits, hands, or feet to traps laid for other animals. In Côte d'Ivoire, bushmeat from numerous species rivals beef as the primary source of meat. One northern Congo town's residents consume 5700 kilograms (12,500 pounds) of bushmeat every week. As logging roads snake into previously undisturbed habitat and new settlers arrive, hunters easily sell their catch in towns, and some bushmeat even finds its way to Europe. Apes are protected in most nations, but enforcing the laws ranges from difficult to impossible.

Orangutans are also hunted, even though they are legally protected throughout their range. Increased logging in remote areas of Indonesia has opened up the rain forest to poachers. As recently as the late 1980s, shops still sold orangutan skulls to curious tourists.

In some regions, great apes are hunted for purported medicinal uses. Although eating primates is taboo in some cultures, in others consuming gorilla flesh is thought to make people stronger, and eating bonobo meat or other parts is believed to enhance sexuality. Markets across Africa sell ape hands, heads, feet, and bones to make soups and stews, or to keep as fetishes.

## The Live-Animal Trade

The trade in live animals is one of the saddest associated with apes. Poachers that shoot a female ape for food may take her infant to sell alive. Other hunters deliberately kill females with dependent young hoping that the baby will bring a good price. Apes are very protective of their young, and an attack on a female with an infant often brings others in the group to her defense. For every infant on sale, at least ten other apes may have died, either trying to protect the youngster or while being taken to market.

Although education programs and stricter regulations have virtually stopped open exports of apes, unscrupulous animal dealers still sell animals on the black market. Across Africa and Asia, orphaned apes are sold or paraded along beaches for tourists to see and photograph. In the late 1980s, as many as 1000 young orangutans were smuggled from Indonesia to Taiwan to serve as nightclub attractions under appalling conditions.

In the past, medical researchers depended heavily on wild-caught apes for their experiments. Today, the largest user of apes, the United States, has banned the import of chimpanzees for medical research, and laboratory demand must be met by captive-breeding programs. Researchers use chimpanzees and bonobos because their biology is so similar to that of humans. However, it is one difference in our immune systems that is now receiving special attention. Chimpanzees and bonobos are immune to the effects of the AIDS virus. It is even believed that the AIDS epidemic began when people ate bushmeat infected with a simian version of the virus that then mutated into a new variant, which spread through the human population. By studying how apes resist the virus, researchers hope to learn how to treat humans. The use of apes in this kind of research is unlikely to end any time soon, and it raises countless ethical issues associated with using our close relatives as guinea pigs.

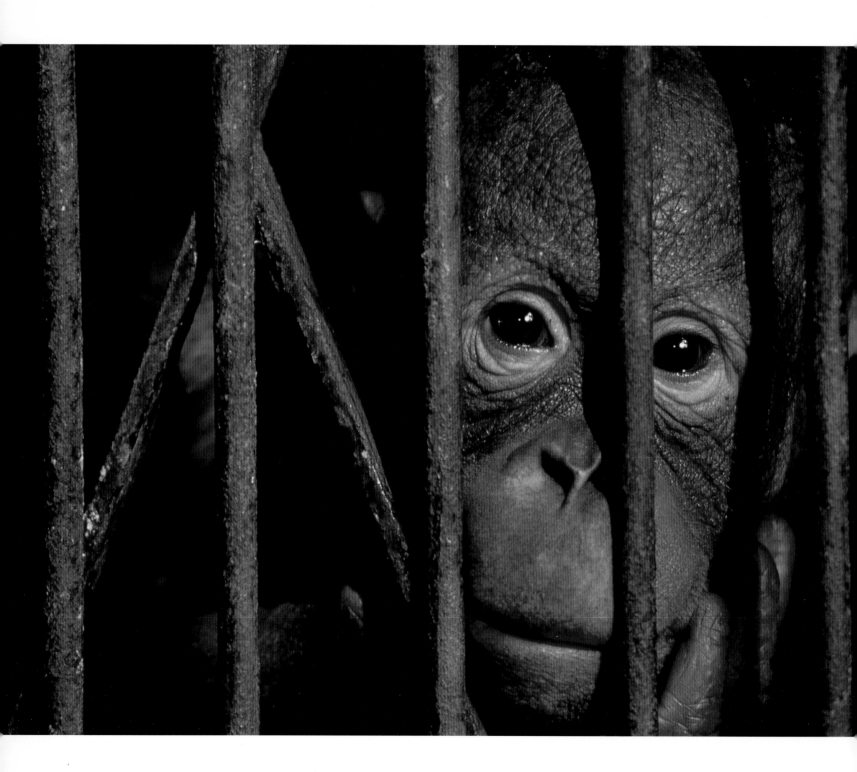

## War and Insurrection

Political unrest, civil war, and international conflicts have blighted many areas in Africa. The human suffering overshadows the ecological impacts, but they are closely related. Before Rwanda's civil war began, tourists from around the world paid US$10 million a year to see mountain gorillas in the wild. In a nation where the average annual income is just US$1,300, slightly more than three hundred mountain gorillas, inhabiting just 0.5 percent of Rwanda's land, were the country's third-largest foreign income earners.

When civil war erupted in Rwanda in the mid-1990s, more than two million refugees fled the fighting and one million settled temporarily on the edge of Congo/Zaire's Parc des Virungas-Sud. Over two years, the refugees cut 36 million cubic meters (47 million cubic yards) of firewood from the edge of the park. The mountain gorillas survived the influx of people, but not without losses. In 1994, a land mine killed a silverback, and, over a seven-month period in 1995, eight gorillas died at human hands. A Congolese army patrol encountered a family of gorillas in May 1997 and shot ten of them. In June 1998, conservationists reported the birth of ten mountain gorillas in the park, but poachers killed two adults just a month later.

Why should people be concerned about the survival of the great apes? The arguments are twofold. Apes have an *intrinsic* value. They are unique and they have an innate right to exist, just as we do. To permit their destruction, either deliberately or through inaction, should be abhorrent to us. Within the environmental community, The Great Ape Project members argue that human rights should become Hominidae rights. To these authors, our similarity to the other great apes far outweighs our differences, and as such the laws that safeguard humans should protect all of the apes.

But beyond their intrinsic value, and perhaps a more concrete, if ignoble, concept for many, is the utilitarian value of apes. They are useful to us. Not only do they give us pleasure by the simple act of watching them, but they can bring valuable revenue to developing nations. The great apes are not ecological oddities, they are integral components of ecosystems, and their conservation can be an entirely selfish act, for in their conservation we may find our own.

If ape populations are healthy, then by inference so are the ecosystems that sustain them, and vice versa. With such a large amount of fruit in their diet, apes ingest a lot of seeds, which they disperse in their feces. Some plants may be completely dependent on apes for seed distribution. At Tanjung Puting Game Reserve in Borneo, orangutans feed on more than two hundred species of fruit and distribute the seeds of over 70 percent of them. In Kibale National Park, Uganda,

98.5 percent of chimpanzee feces contain seeds, and primates may consume and distribute the majority of seeds. Up to 60 percent of Kibale trees could vanish if the forest's frugivores, which also include monkeys and birds, were lost.

Great apes guard the world's largest repository of biodiversity. More than one-quarter of all drugs prescribed in the United States are derived from tropical rain forest plants, and yet less than 7 percent of known tropical plants have been screened for medicinal use. If we protect the apes, we protect the phenomenal medicine cabinet that makes up their environment.

We can also learn medicinal practices from our ape relatives. Geophagy and leaf-swallowing could be adapted to treat both people and livestock at a fraction of the cost of western medicine and without the risk of resistance developing in the target organism, as so often happens after chemical treatments.

As our understanding of great ape society and behavior increases, we learn more about our own evolution. Paleontologists may unearth bones but animal behaviorists add a mind to the body. More than any other group of animals, great apes help us put our own origins in perspective. We are not separate from the animals, we are simply another kind of animal.

The great apes will not survive if all we can do is keep a few in zoological collections. There are no mountain gorillas and few bonobos in captivity, and most of the chimpanzees in zoos are hybrids. Zoos can raise awareness and they can educate, but they cannot rebuild rain forest habitat or house enough apes to ensure a long-term future.

Great ape survival depends on protecting their habitat. Environmental organizations are working increasingly with local governments and councils to give people alternative sources of income, for example through tourism or village-based industries, so that they do not need to poach or harvest bushmeat. Local people must participate or efforts to conserve the great apes will be doomed to

fail. Increasingly, both governments and individuals are realizing the value of native wildlife and the importance of conservation.

We can ensure the survival of our closest relatives, but it will take concerted and deliberate action. Losing a handful of species may seem insignificant compared with the millions that will be lost as the tropical forests are felled, but if we fail to save those with whom we share so much, and for whom we have such motivation to save, what chance is there for the rest? As far as we know, we are the only great ape that can foresee our own deaths and the deaths of others. We are also the only great ape that holds the future of entire species in our hands. With foresight comes responsibility. And with responsibility comes accountability, for surely future generations will judge our actions and our results.

FACING PAGE

*The more we learn about chimpanzees and the other great apes, the closer we are to a complete understanding of ourselves.*
MICHAEL NICHOLS/NGS
IMAGE COLLECTION

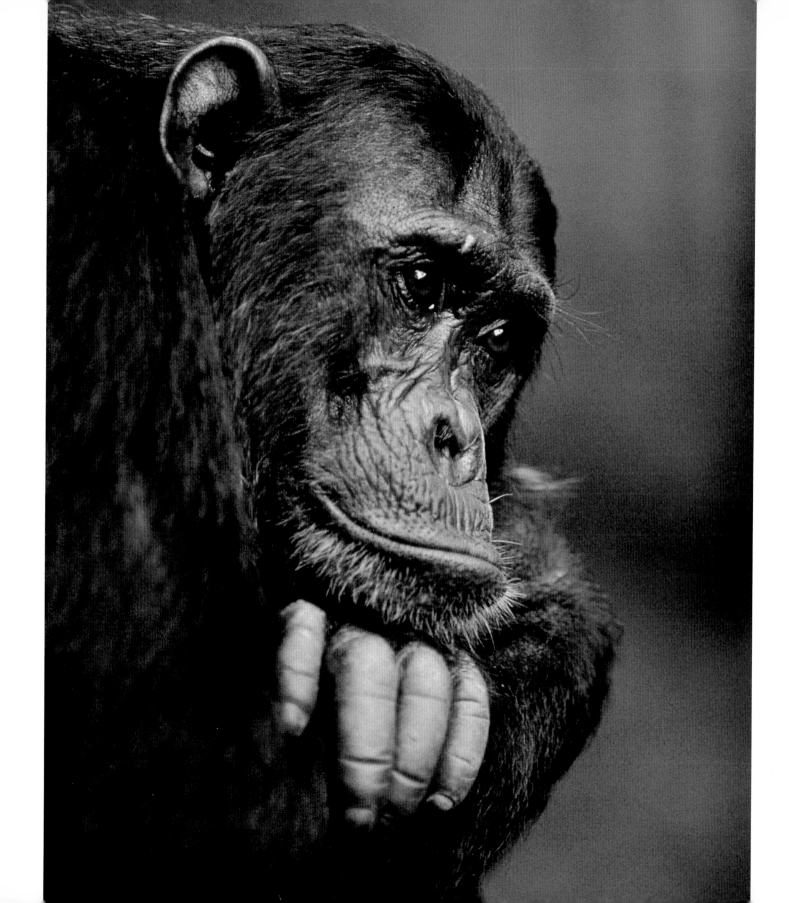

# FOR FURTHER READING

Cavalieri, Paola, and Peter Singer, eds. *The Great Ape Project*. New York: St. Martin's Press, 1993.

De Waal, Frans, and Frans Lanting. *Bonobo: The Forgotten Ape*. Berkeley and Los Angeles, California: University of California Press, 1997.

De Waal, Frans. *Chimpanzee Politics: Power and Sex Among Apes*. Baltimore and London: Johns Hopkins University Press, 1998.

Diamond, Jared. *The Third Chimpanzee*. New York: HarperPerennial, 1993.

Fleagle, John G. *Primate Adaptation and Evolution*. San Diego: Academic Press, 1999.

Fossey, Dian. *Gorillas in the Mist*. Boston: Houghton Mifflin Company, 1983.

Galdikas, Biruté F. M. *Reflections of Eden: My Years with the Orangutans of Borneo*. Boston: Little, Brown & Company, 1996.

Ghiglieri, Michael Patrick. *The Chimpanzees of Kibale Forest: A Field Study of Ecology and Social Structure*. New York: Columbia University Press, 1984.

Goodall, Jane. *In the Shadow of Man*. New York: Houghton Mifflin Company, 1988.

Goodall, Jane. *Through a Window: My Thirty Years with the Chimpanzees of Gombe*. New York: Houghton Mifflin Company, 1990.

Knott, Cheryl. "Orangutans in the Wild." *National Geographic*, Vol. 194, No. 2, August 1998.

Linden, Eugene. "A Curious Kinship: Apes and Humans." *National Geographic*, Vol. 181, No. 3, March 1992.

Linden, Eugene. "Bonobos, Chimpanzees with a Difference." *National Geographic*, Vol. 181, No. 3, March 1992.

McGrew, William C. *Chimpanzee Material Culture: Implications for Human Evolution*. Cambridge: Cambridge University Press, 1992.

McGrew, William C., Linda F. Marchant, and Toshisada Nishida, eds. *Great Ape Societies*. Cambridge: Cambridge University Press, 1996.

Nadler, Ronald D., Biruté F. M. Galdikas, Lori K. Sheeran, and Norm Rosen, eds. *The Neglected Ape*. New York and London: Plenum Publishing Corporation, 1995.

Nishida, Toshisada, ed. *The Chimpanzees of the Mahale Mountains: Sexual and Life History Strategies*. Tokyo: University of Tokyo Press, 1990.

Patterson, Francine, and Eugene Linden. *The Education of Koko*. London: André Deutsch Limited, 1982.

Peterson, Dale, and Jane Goodall. *Visions of Caliban: On Chimpanzees and People*. Boston: Houghton Mifflin Company, 1994.

Schaller, George B., and Michael Nichols. *Gorilla: Struggle for Survival in the Virungas*. New York: Aperture, 1992.

Schaller, George, B. *The Year of the Gorilla*. Chicago: The University of Chicago Press, 1997.

Schwartz, Jeffrey H., ed. *Orang-utan Biology*. Oxford: Oxford University Press, 1988.

Smuts, Barbara B., Dorothy L. Cheney, Robert M. Seyfarth, Richard W. Wrangham, and Thomas T. Struhsaker, eds. *Primate Societies*. Chicago and London: The University of Chicago Press, 1987.

Wrangham, Richard W., William C. McGrew, Frans B. M. de Waal, and Paul G. Heltne, eds. *Chimpanzee Cultures*. Cambridge: Harvard University Press, 1994.

For Internet links to primate sites, visit www.michellegilders.com.

# INDEX